IMAGES
of America

ROCKAWAY
TOWNSHIP

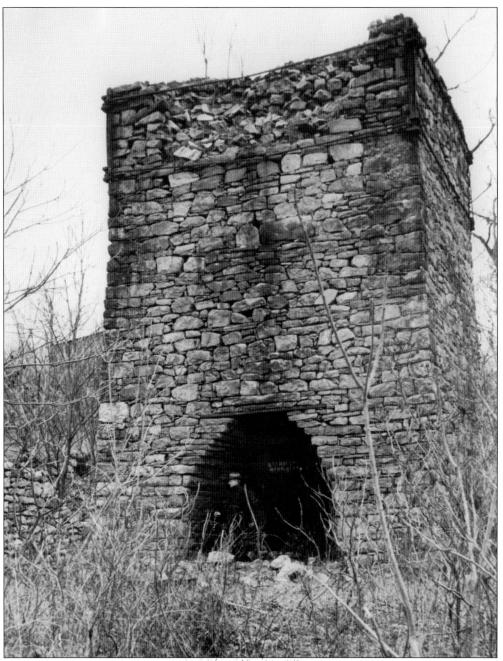

In 1862, Andrew Bell Cobb built this 38-foot charcoal furnace, expecting to make money selling shot and shell to the northern army during the Civil War. When he discovered that he could not meet competitive prices and that his profit would be negligible, he ceased operations within two years of the commencement of business. (Courtesy of Historical Society of Rockaway Township.)

ON THE COVER: The photograph on the cover shows miners in the Richard Mine standing by a drill jumbo. This piece of equipment was used for driving holes into the side of the mine wall to make openings for dynamite. (Courtesy of Historical Society of Rockaway Township.)

IMAGES
of America

ROCKAWAY TOWNSHIP

Eleanor C. Mason and Patricia A. White

ARCADIA
PUBLISHING

Published by Arcadia Publishing
Charleston SC, Chicago IL, Portsmouth NH, San Francisco CA

Printed in the United States of America

Library of Congress Control Number: 2009940226

For all general information contact Arcadia Publishing at:
Telephone 843-853-2070
Fax 843-853-0044
E-mail sales@arcadiapublishing.com
For customer service and orders:
Toll-Free 1-888-313-2665

Visit us on the Internet at www.arcadiapublishing.com

CONTENTS

ACKNOWLEDGMENTS

We appreciate the foresight of the original board of trustees and directors of the Rockaway Township Library, who gave permission for the Historical Society of Rockaway Township to house their collection in the library. This joint partnership has allowed the preservation of the historical society's collection, which includes the photographs that appear in this book. Thank you also to the township municipal government, whose support and encouragement throughout the years has furthered this endeavor.

A special thanks to Thomas S. Brackin, Dick Kehoe, Diane Power, and Ingrid Sceusi. Without their dedicated assistance, this book would not have been possible.

Also we wish to thank all those who donated or loaned their photographs and devoted their time to share their experiences of living in Rockaway Township, including Ronald Shea, the Will family, Rick Lillis, the Hurley family, John Collict, George Coulthard, Evelyn Hammaren, Jim Little, Tom Weaver, Tom Chamberlain, Mary Twilley, John Kolic, the Bostedo family, Lisa Genovese, Jan Gminder, Evelyn Karpack, Gerd Andreassen, Doug Eike, Tom Dobbins, and Ellen Crane. It is not possible to list all the people who had faith in our concept for a picture book of the township, but whether you donated one photograph or many, we are grateful to you. Please forgive any oversight if we have neglected to mention your name. Throughout the years, many photographers, such as Ed Monski, Vincent Cole, Art Steinberger, and Phil Reynolds, have been invaluable in providing the historical society with excellent reproductions of these photographs, and we thank you. We appreciate the diligence and guidance of Erin Rocha, our editor at Arcadia. All of your contributions have made it possible to present to you, the readers, this pictorial history of Rockaway Township.

Unless otherwise indicated, all images appear courtesy of the Historical Society of Rockaway Township.

INTRODUCTION

Rockaway Township, incorporated in 1844, was originally part of Pequannock and Hanover Townships. The name Rockaway has its origins in the Lenape Native American language. Currently it is the largest municipality in Morris County. The township is 11.6 miles long and 5.2 miles wide, with an area of 45.3 square miles. Its population is approximately 23,000.

Rockaway Township's claim to fame is its rich iron heritage, which has impacted our country's history from the 1700s through the 1970s. Numerous mines were located throughout the township. The Mount Hope and Hibernia Mines began operations in the early 1700s. Both of these mining areas had furnaces that provided George Washington and the Continental Army with the weapons of war. As people came to work in the mines, communities developed in different parts of the town. Each area had its own stores, schools, places of worship, homes, and mining buildings.

The iron industry continued to flourish in the 1800s and into the 1900s. As a result of the depletion of the forests, which provided fuel for the furnaces, the furnaces were forced to close. Consequently, Rockaway's iron ore had to be transported first on the Morris Canal and later on railroads to be refined in coal-fired furnaces in Pennsylvania.

In the 1800s, iron ore was discovered in the Mesabi Range in Minnesota. This ore was more accessible than the ore mined in the East, and the mines in Rockaway could no longer compete financially. In the 1900s, the mines slowly began to cease operations, and people moved away to find jobs in other locations.

As the iron industry was declining, areas of Rockaway Township such as Green Pond, Lake Telemark, and White Meadow Lake became vacation destinations for city residents within commuting distance. Children came to enjoy outdoor experiences at camps located in the township.

At the same time Rockaway was developing as a vacation area, people were also being attracted to settle in the area to work at Picatinny Arsenal, which became a major employer in Morris County. The history of Picatinny goes back to 1749, when Jonathan Osborne established a forge known as Middle Forge at the foot of Picatinny Peak. It later became part of the Mount Hope Ironworks, which was owned by John Jacob Faesch. In 1879, the Dover Powder Depot was created on this property. It later developed into an arsenal producing ammunition and explosives, and the facility was renamed Picatinny Arsenal in 1907.

With the completion of Route 80 in the 1970s, which made access to larger cities possible, Rockaway Township began to grow and prosper as a suburban community. People could live in "the country" and commute to work in the city.

Preservation of our heritage in photographs and documentation are valuable assets, and we invite you to join us on a visit into our past.

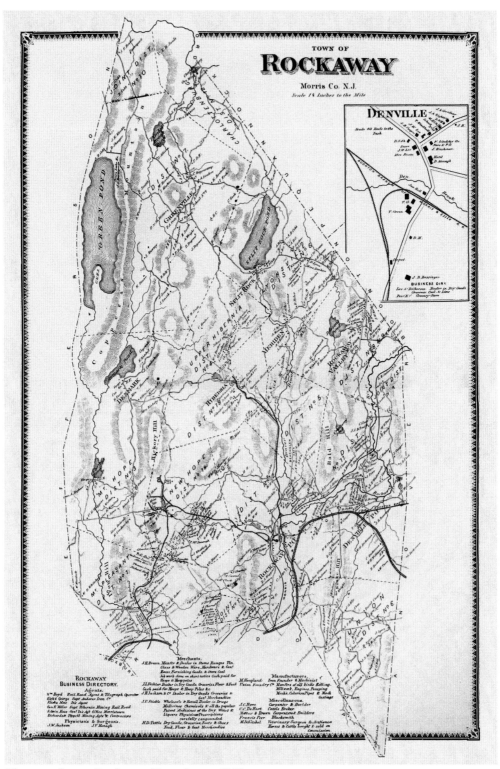

This map depicts Rockaway Township in 1868.

One

THE MOUNT HOPE TRACT

In 1710, an outcropping of iron ore in the form of a cliff 100 feet high was discovered at Mount Hope. The property was purchased by Jacob Ford Sr. in 1749. His son, Jacob Ford Jr., built the present-day Ford-Faesch House at Mount Hope c. 1772.

In 1772, ironmaster John Jacob Faesch leased the house and adjoining property and built the Mount Hope Furnace, which operated from 1772 to 1825. During the Revolutionary War, this furnace was actively engaged in producing shot, shells, and other hardware for the Continental Army.

John Jacob Faesch eventually purchased the 6,271-acre Mount Hope Tract. Located in the southwestern portion of Rockaway Township, this tract contained rich deposits of iron ore. When Faesch died in 1799, the tract was divided into 34 lots of land. Two lots, totaling 2,163 acres, contained the Mount Pleasant, Baker, Richard, Allen, Teabo, and Mount Hope Mines. Two mines, Mount Hope and Richard Mine, produced over 11.5 million tons of ore in their lifetime.

Prior to the completion of the Morris Canal, the iron ore supplied by these mines was processed in local blast furnaces, forges, and bloomeries. After the development of anthracite-fired blast furnaces in eastern Pennsylvania in the late 1830s, iron ore from Rockaway Township mines was transported on the Morris Canal to the Pennsylvania furnaces.

Communities such as Mount Hope, Teabo Mine, and Richard Mine grew as the production of iron ore increased. Miners' homes, general stores, churches, and saloons were constructed. Mount Hope had a post office, Teabo had a temperance hall and a bottling works, and Richard Mine had a butcher shop.

Competition from iron ore mining operations in the upper Midwest caused most of the mines to close before or shortly after 1900. Only the Richard Mine and the Mount Hope Mines continued in operation, until 1958 and 1978 respectively.

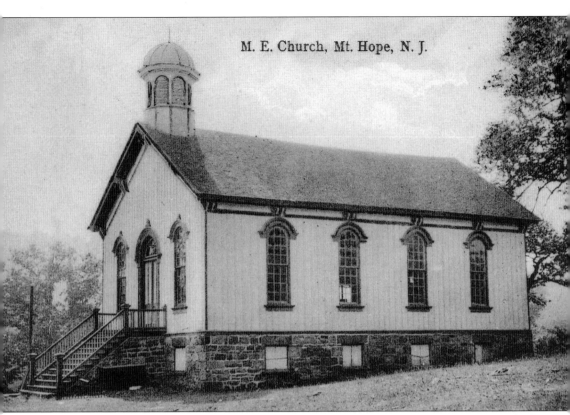

M. E. Church, Mt. Hope, N. J.

Although a Methodist community started in Mount Hope in 1831, the Mount Hope Methodist Episcopal Church, also known locally as the Mount Hope Miners' Church, was not finished and dedicated until August 1868. The mining company erected the church and provided a parsonage for the first full-time minister, Rev. C. Clark, who was appointed in 1869.

OPPOSITE PAGE: This picture depicts the interior of the Mount Hope Methodist Church as it looked before it was redecorated. After the church was closed, it was vandalized and deteriorated from lack of attention. The building has been purchased by the Morris County Park Commission and is presently undergoing renovations.

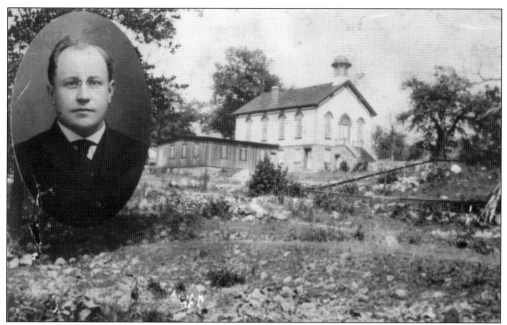

Over the years, many improvements were made to both the interior and exterior of the church. However, the church has remained structurally unchanged. A dwindling of parishioners forced the church to close in 1982. The identity of the inset portrait is unknown.

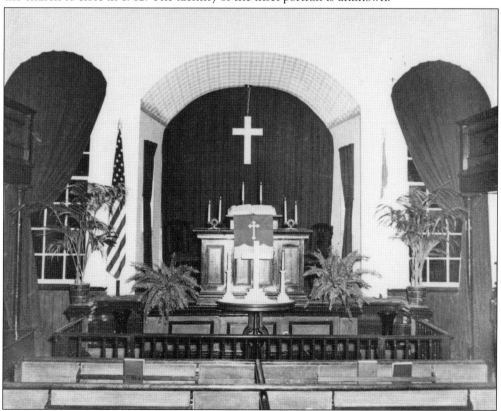

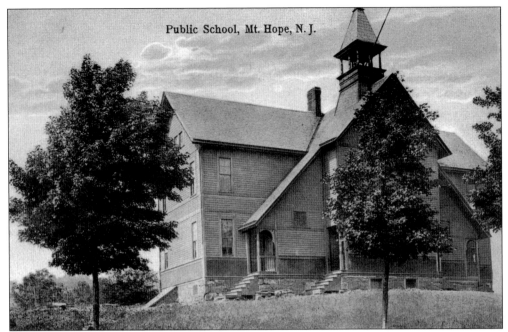

Public School, Mt. Hope, N. J.

Built in 1885, the Mount Hope School was located on the grounds of the present-day Catherine Dwyer School. A newspaper article stated that in 1885, Principal James O. Cooper had been "re-engaged" at the Mount Hope School.

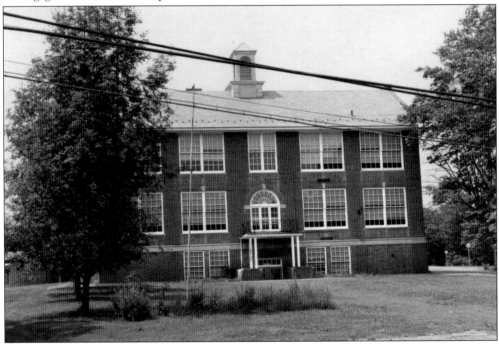

In 1921, the 1885 school was replaced by a two-story wooden structure containing two classrooms on each floor. A masonry addition consisting of two rooms on each floor was added to the front of the existing school in 1930. When it was no longer needed, the building was demolished in December 1981.

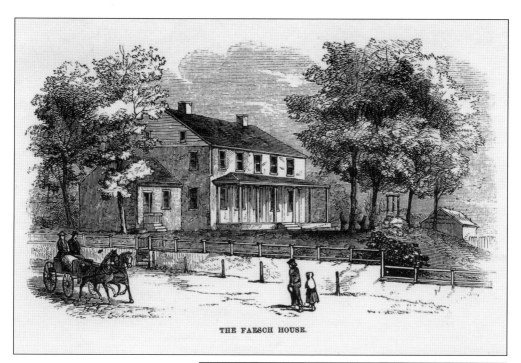

THE FAESCH HOUSE.

Colonel Jacob Ford Jr. built the Ford-Faesch Manor House c. 1772. This three-story house constructed of native stone had twelve rooms, nine fireplaces, and a smokehouse in the attic. The Ford-Faesch House is on the State and National Registers of Historic Sites, and is being restored by the Historical Society of Rockaway Township in conjunction with Rockaway Township and donations and grants supplied by various entities.

In 1772, Jacob Ford Jr. leased the Mount Hope property to John Jacob Faesch, a Swiss immigrant, who erected a blast furnace on the property. Faesch was recognized as an American patriot, civic leader, and county judge. In 1787, Faesch represented Morris County as a delegate to ratify the U.S. Constitution.

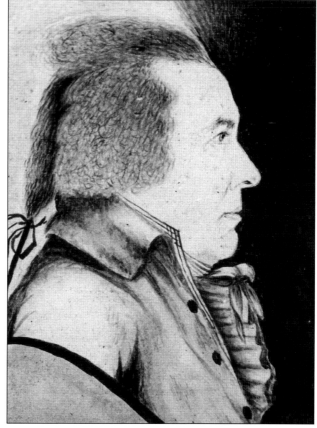

13

So important were the Mount Hope iron works for the war effort that George Washington permitted Faesch to employ 35 Hessian prisoners who had been captured at the Battle of Trenton. Faesch's plantation included 400 apple trees, a gristmill, a hemp mill, farming land, and a hunting meadow, which is shown in this photograph.

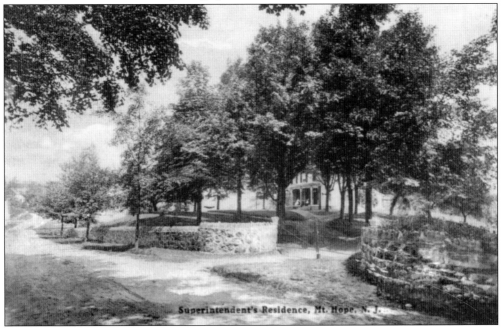

Owned by the Mount Hope Mining Company, this was the home of Mattson Williams prior to his promotion to superintendent in 1879. When Supt. Richard Stephens, who was living at the Faesch House, died that year, the house became known as the Superintendent's House. At least two other superintendents resided there until the mines closed in 1893. When Empire Steel reopened Mount Hope, it was utilized as a boardinghouse.

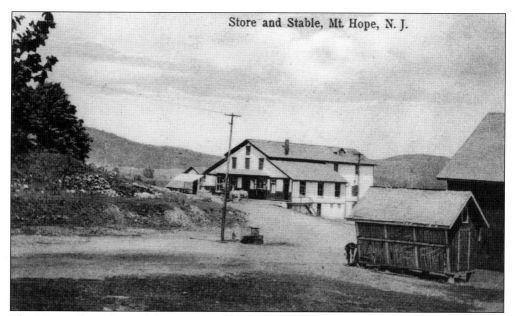

The Mount Hope General Store and stable, property of the Empire Steel and Iron Company, sold large quantities of mining supplies, groceries, and general merchandise. A post office also operated there until 1907. Fire destroyed portions of the building, but it was later rebuilt and now houses the Tilcon New York office.

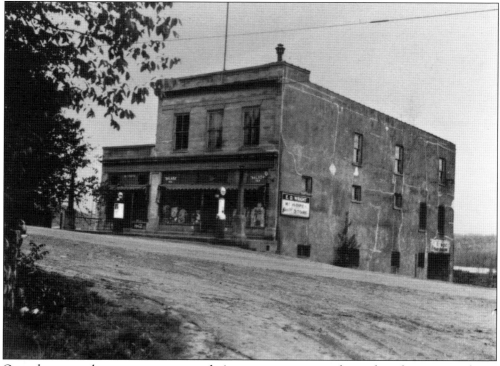

Over the years, the store was renovated. At one time, a tavern located in the rear on a lower level was patronized by many baseball players and their fans when ball games were played on a field located behind the store.

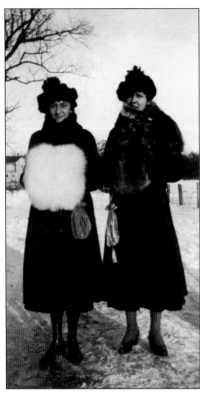

Mary Wellington Hocking (left) and her cousin Nila Wellington are enjoying each other's company on a winter day in Mount Hope, around World War I. While most men in Mount Hope worked in or at the mines, many women worked outside the home at other types of jobs. For 40 years, Mary Hocking held the position of Rockaway Township tax collector. (Courtesy of Ecla Wellington.)

On August 13, 1935, Mount Hope Fire Company No. 2 was created, and Leo Finnegan was elected as its first chief. A variety of activities were held to raise money for needed equipment. In 1937, a 1922 Reo Fire Pumper was purchased from Mount Tabor Fire Company for $400. The Rescue Squad was formed in 1948. Over the years, additions and improvements have been made to the original building.

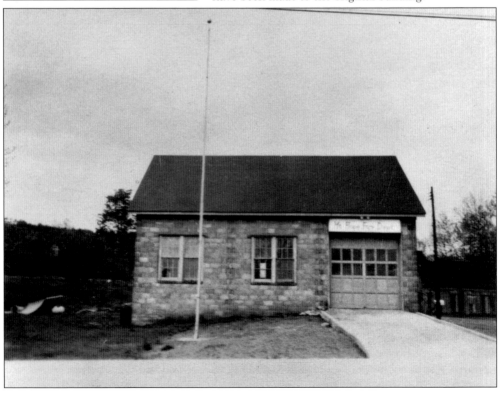

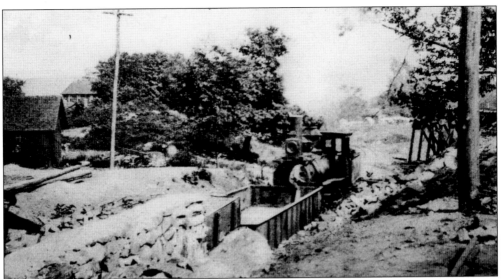

Located in Mount Hope were some of the oldest iron mines in the United States, which produced over six million tons of iron ore. The mines consisted of a large complex of shafts, tunnels, and open pits. At one time a gravity tram railroad transported iron ore from Mount Hope to the Morris Canal in Rockaway Borough.

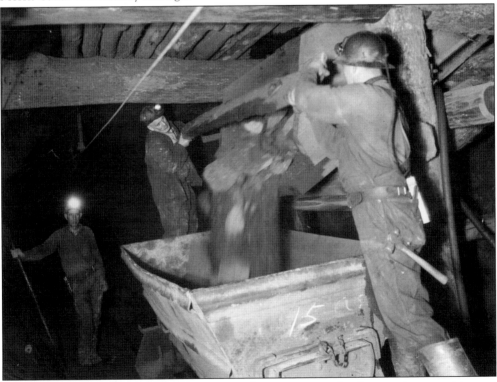

A miner looks on as two other miners open a chute gate, emptying iron ore into a waiting ore car. While this operation was done electronically in some mines, many miners preferred to do it manually, as shown in this photograph. Curiously, production was the same whether done by hand or by machine.

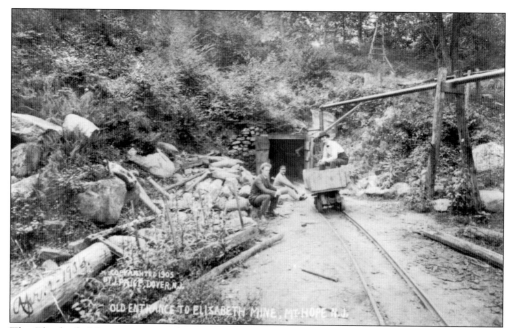

The Elizabeth Mine was an early Mount Hope mine named for John Jacob Faesch's wife. By the 1880s, it was yielding about 30,000 tons of iron ore annually. Initial shafts were dug on the southwest vein, but they were depleted by 1900. This mine was located to the west of the beach at Mount Hope Pond.

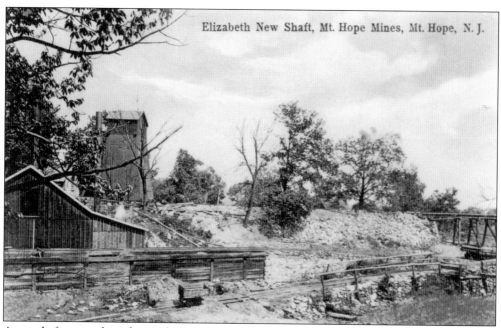

A new shaft was sunk on the northwest side of the Elizabeth Mine and was named the Elizabeth New Shaft. According to state geologist reports, by 1909 the mine was 500 feet deep and later reached a final depth of 1,120 feet. This mine was one of the most productive in Rockaway Township.

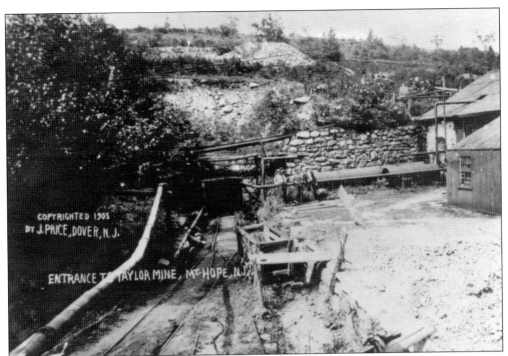

The Taylor Mine was located in Mount Hope and supplied ore from the Taylor or "jugular" vein. This mine operated from the early 1860s until 1903, and was named for Moses Taylor, who purchased the Mount Hope Mining Company in 1853. Iron ore from this mine was shipped on the Morris Canal to Washington, New Jersey, and then by rail to anthracite blast furnaces in Scranton, Pennsylvania.

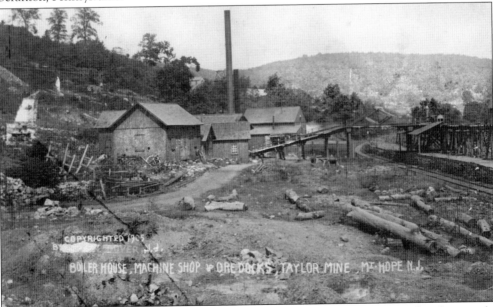

The boiler house, machine shop, and ore docks at the Taylor Mine can be seen in this photograph. Notice the statue of the Virgin Mary in the left upper section of this photograph. Perhaps the miners felt she would protect them while they were working in a dangerous occupation.

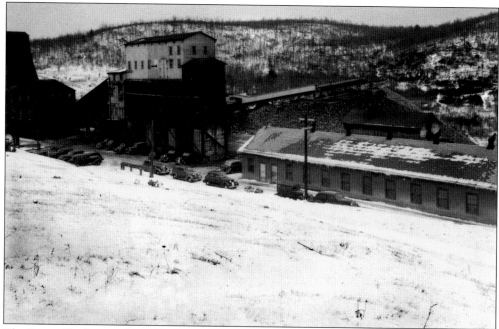

The Brown Shaft opened in 1900 to mine the Taylor, Elizabeth, Leonard, and Carlton ore deposits. To the left are the headframe and the shafthouse. The lump ore mill is to the center left, and the long building is the change house. The Brown Shaft was the only shaft at Mount Hope used to raise ore from 1911 to the opening of the New Leonard shaft in 1944.

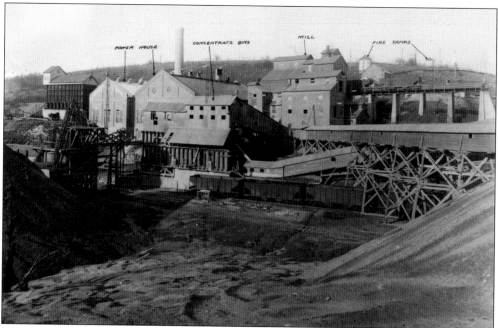

Taken around 1930, this photograph shows an expanded original Leonard Mine complex. Iron ore from both the Leonard Mine and the adjacent Brown Shaft was raised through the Brown Shaft and then processed at this complex. In 1944, both the Leonard Mine and the Brown Shaft were shut down upon the opening of the New Leonard Mine.

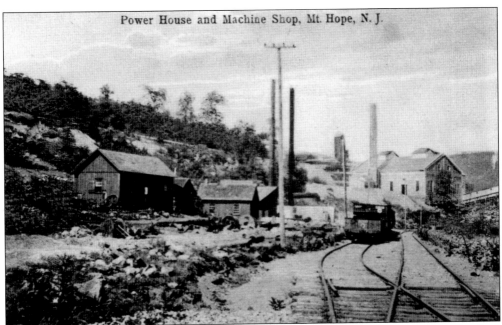

The buildings pictured are part of the original Leonard Mine Complex at Mount Hope. The shaft for this mine was sunk in 1906 to mine ore from the Leonard or Side Hill deposits. The building on the right is still being used by Tilcon New York, the current owner.

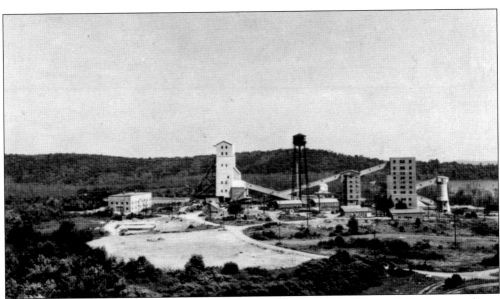

In the early 1940s, the New Leonard Complex was built. The New Leonard Shaft was a three-compartment concrete-lined shaft over 2,700 feet deep, the deepest vertical shaft in the East. On the left is the hoist house and compressor. To the right are the headframe, water tower, lump ore plant, concentrate mill, and surge bin. This complex operated from 1944 until final closure in 1978.

This view shows a row of miners' homes located near Mount Hope Pond. The backs of these homes faced the pond, and they fronted today's road to Picatinny Arsenal. Miners rented their homes from the mining company. The only source of heat was a wood-burning stove in the kitchen. Water was obtained from a nearby community well. In the 1920s, these houses finally had the luxury of electricity.

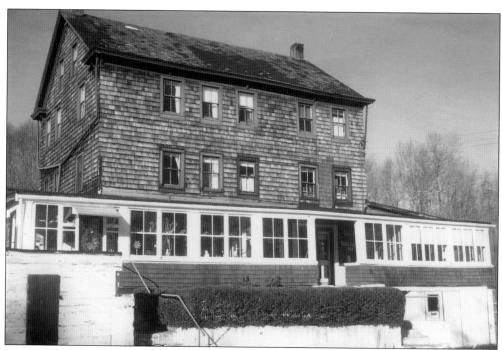

Built in the late 1880s, James's General Store was located on Teabo Road. The post office from the Mount Hope General Store was briefly located here in the 1890s. Mr. Kearney, the original owner, sold the property to William James Sr. in 1913. William James was employed at the Mount Hope Mine before he purchased the store, which he and his wife, Lucinda, operated for over 30 years.

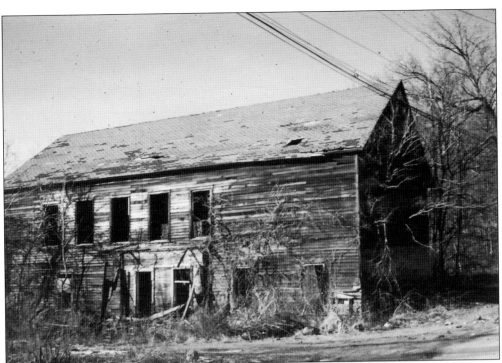

The Union Hall, located in the Teabo area adjacent to James's General Store, was used by the miners of the Mount Hope and Richard Mine for meetings. Occasionally it was rented for dances and other events. A fire destroyed this building.

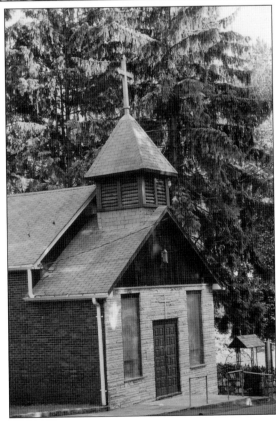

The history of the Saint Bernard's congregation goes back to the 1700s. In 1774, Fr. Ferdinand Steinmeyer, also known as "Father Farmer," traveled by horseback to administer the sacraments to the Catholics in Mount Hope. In 1869, Saint Bernard's Church was erected on a plot of land donated by John Corrigan. The church has been renovated over the years, and a shrine was built adjacent to the church in 1935.

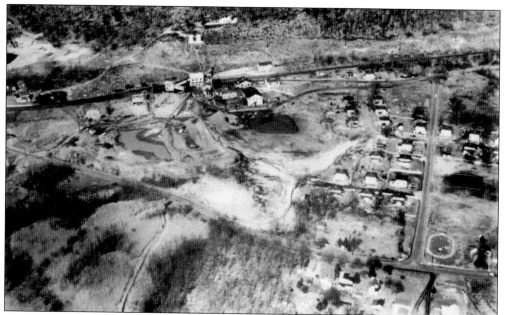

This aerial view shows the Sweetser Shaft and miners' homes at Richard Mine around 1950. This mine was named after Richard Faesch, who acquired the property from his father's estate in 1813. The Richard Mine Complex was eventually sold to the Thomas Iron Company in 1856. Over the next 67 years, millions of tons of iron ore were shipped to anthracite blast furnaces in Pennsylvania. Richard Mine closed in 1958.

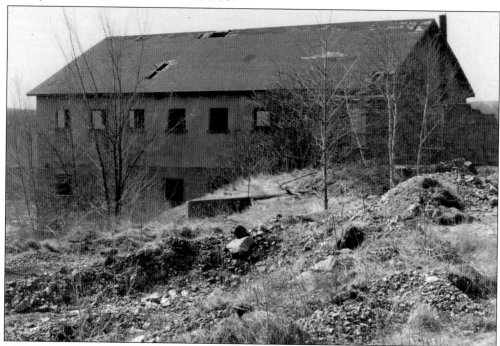

The change house at Richard Mine's Sweetser Shaft provided facilities for miners to change work clothes and shower after each work shift. In 1951, over 200 men were employed at the Sweetser Shaft.

The Sweetser Shaft at Richard Mine was a four-compartment vertical shaft that was completed to a final depth of 1,244 feet in 1930. The shaft was named for Ralph Sweetser, president of the Thomas Iron Company. Since the early 1800s, the various shafts and inclines that made up the Richard Mine Complex have produced over 5.7 million tons of high-grade magnetite iron ore.

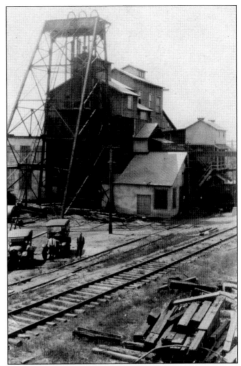

Some miners at work underground in the Richard Mine are shown in this photograph. The mines were cold, wet, and dark. As time passed, new equipment and improvements made mining safer and more efficient.

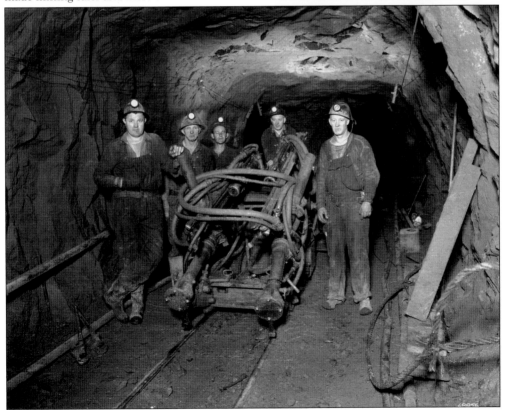

The superintendent of Richard Mine lived in this house. On either side of this large house can be found the foundations of miners' homes. The site of Union Picnic Grounds was once located nearby.

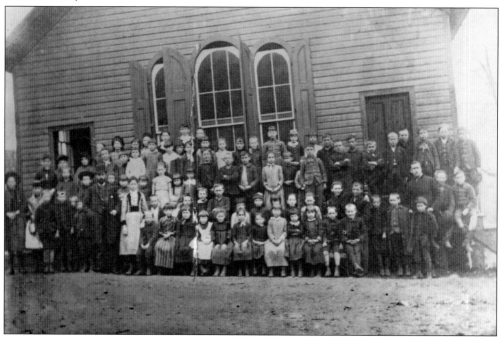

The first Mount Pleasant School was built in the late 1880s. Due to the hilly terrain of the property, three classrooms were constructed on different levels. In 1895, some 215 children were enrolled at this school, and it was valued at $3,000.

This Mount Pleasant School was the second school located on this property, and it was built in 1913 at a cost of approximately $9,000. The wooden structure had two classrooms on each floor.

In 1967 the Board of Education utilized the Mount Pleasant School for offices and eventually sold it to the New Jersey Irish American Association. Notice the interesting fire escape on the left.

ROCKAWAY TOWNSHIP SCHOOLS.

School No...4..............Mt. Pleasant........N. J.

Scholarship Report of....Le Roy Little.................... Grade....3......

Month	Days Absent	Times Tardy	Deportment	Arithmetic	Oral Arith.	Geography	Language	Literature	Civics	History	Reading	Spelling	Writing	Hygiene	Physical Tr.	Attitude	Citizenship	193 1
September	0	0	A	C₁₆	B		B			C₁₆	B	B	B	B	a			
October	1	0	A	C	C		B			C	C	B	B	B	a			Proficiency in studies
November	0	0	A	C	C		C			C	B	B	B	B	a			is indicated by the
December	0	0	A	B	B		C			C	B	B	A	A	a			letters A, B, C, D
January	0	0	A	C	C		B			B	a	B	A	a				and E.
February	0	0	A	B	B		B			C	a	a	a	a				
March	0	0	A	B			B			C	a	a	a	a				A—excellent
April	0	0	A	B	C		B			C	a	B	a	a				B—good
May	0	0	A	B	B		a			B	a	a	a	a				C—passable
June	0	0	A	B	B		a			B	a	a	a	a				D—failure
																		E—bad failure

Promoted to fourth grade

........Helen Johnson........Principal. Virginia Maple........Teacher.

(OVER)

A 1931 report card for a third grade student attending the Mount Pleasant School shows that grades were given in a variety of subjects on a monthly basis. Numbers next to grades indicated reasons for lower grades. The supervisor named on the report card is Dennis B. O'Brien. Today's Dennis B. O'Brien School, located near the Rockaway Townsquare Mall, was named in his honor.

To Parents or Guardians.

This report is sent to you at the close of each school month.

The letter A signifies that the pupil's work is practically above criticism. It is seldom given. B signifies that the work done is good. Any mark below B is subject to criticism. For instance, a child receiving C, D or E in a subject will find a small figure to the right of it, which refers you to the reason for the low standing or failure, given below. A small 6 would show that the child wastes time, hence the low average, etc.

Attitude Towards Work.	Recitation.	In General.
1 lacks earnestness and purpose	9 seldom does well	17 timid and self-conscious
2 does not show right spirit	10 comes poorly prepared	18 immature
3 does not apply....self	11 gives up easily	19 slow to comprehend
4 lacks perseverance	12 lacks power to express ideas	20 insufficient home study
5 indolent; listless	13 inattentive; indifferent	21 too many outside interests
6 wastes time	14 careless ; inaccurate	22 too many studies
7 copies; depends on others	15 easily confused	23 poor health, tired out
8 shows improvement	16 capable of doing better	24 irregular attendance

Parent or guardian will write their name in proper place and return to teacher.

D. B. O'BRIEN, Supervisor.

SEPT.	Irene Little	FEB.	Mrs. Irene Little
OCT.	Irene Little	MAR.	Mrs. Irene Little
NOV.	Mrs. Irene Little	APRIL	Mrs. Irene Little
DEC.	Mrs. Irene Little	MAY	Mrs. Irene Little
JAN.	Mrs. Irene Little	JUNE	

28

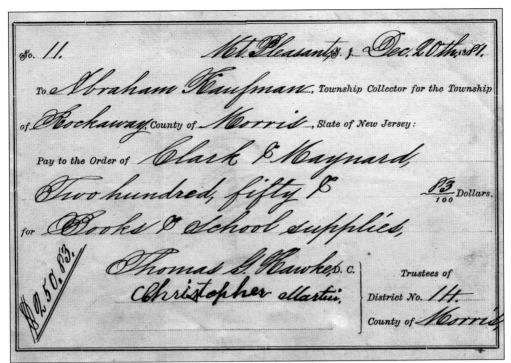

This 1881 voucher for books and school supplies at the Mount Pleasant School is for the amount of $250.

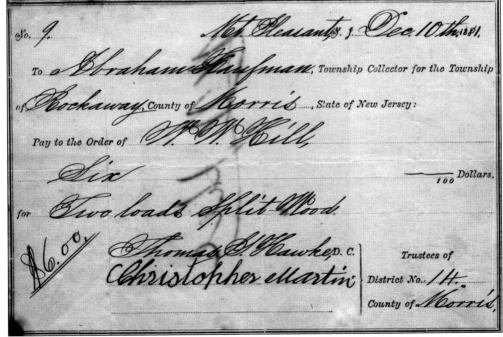

The Mount Pleasant School was heated by wood-burning stoves. This voucher for $6 dated December 10, 1881, is for two loads of split wood to heat the school.

Camp Indawoods, which was owned by R. C. and M. F. Hunt of Denville, was an exclusive family camp consisting of bungalows, tents, and tent sites that were available for rent. Day membership was also an option.

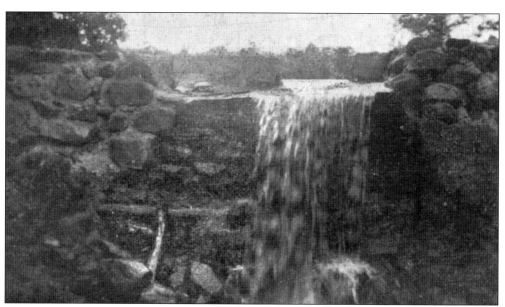

An article from the *Rockaway Record* of August 6, 1931, addresses a trip of young ladies from Livingston who came for the weekend. They occupied Fortune Cottage and evidently spent a wonderful weekend at the camp hiking, singing around the campfire, and swimming. Presently, this property is the location of the municipal complex on Mount Hope Road.

Two

UPPER AND LOWER HIBERNIA

Hibernia, which consisted of two separate mining communities, is located about 3 miles north of Rockaway Borough. Upper Hibernia, also called Oreland, was situated at the top of the mountain, and Lower Hibernia was located at the base of the mountain. Iron ore was first obtained from the Hibernia mines as early as 1722. Lord Stirling, who later became a general in the Continental Army, founded the Adventure Furnace in 1765, which was renamed the Hibernia Furnace in 1767. Important products made at this furnace included cannonballs, shot, and other supplies needed by the patriot troops.

Hibernia experienced rapid growth during the immediate post–Civil War era due to the mining industry. As people moved into the area, homes, stores, churches, and schools were constructed to accommodate the miners and their families. Over its nearly 200-year history, the Hibernia mines became an intricate maze of horizontal and vertical shafts. A total of 12 vertical shafts were sunk, two of which reached depths of 1,600 and 2,800 feet. The Hibernia mines continued to yield a high-grade magnetite iron ore until they closed in 1913. At that time, they had the distinction of being among the top three iron-producing mines in New Jersey.

Although the mines have closed, evidence still exists in Lower Hibernia of this once-active mining community. Miners' homes, buildings, and foundations continue to tell a story of the past.

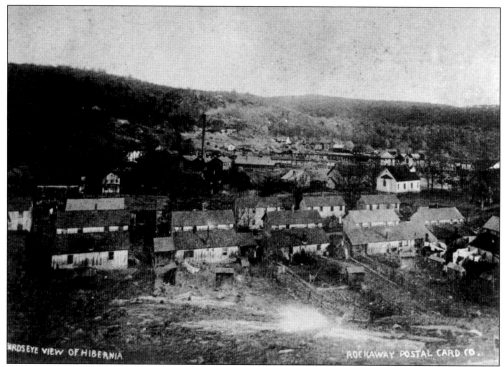

This 1907 bird's-eye view of Hibernia shows two- and three-family dwellings owned by various mining companies. Above the mining homes to the right is the Methodist Episcopal Church. In the background can be seen the elevated railroad, which was used to transport iron ore from the mine tunnel to the crusher.

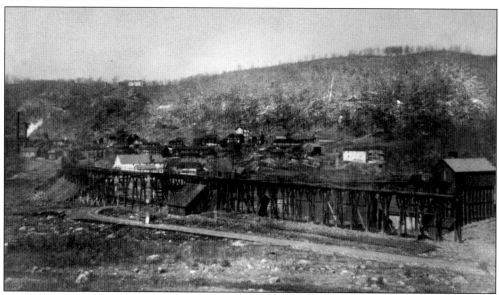

Taken in 1898, this photograph shows the Hibernia Elevated Railroad coming from the Hibernia Tunnel, passing in front of the general store and post office, and ending at the crusher, which is on the right. In the foreground is the old Green Pond Road. In the background are numerous miners' homes, and on top of the mountain Saint Patrick's Roman Catholic Church can be seen.

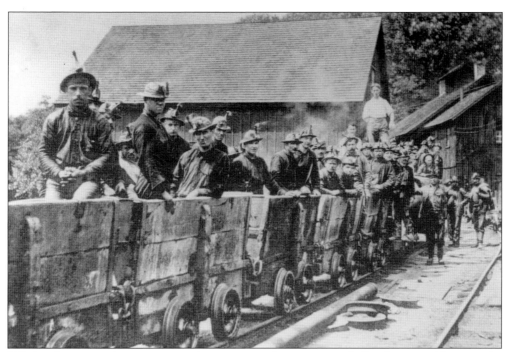

Filled with miners, this ore train is about to enter the mine tunnel. On the miners' hats, smoke is coming from their sunshine lamps, which were used for light in the dark mine. The ore train was pulled by a locomotive, which was about six feet in height.

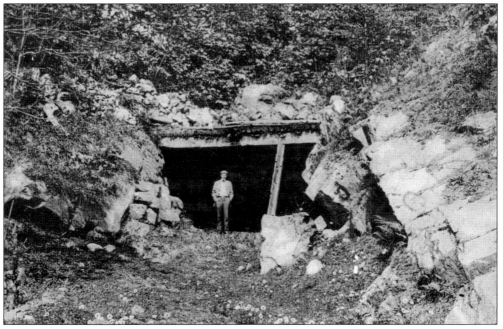

Arthur Hart is standing at the entrance of the abandoned iron mine tunnel in Hibernia. In the 1880s, it was known as the Glendon Tunnel, and it extended as far as the Wood Mine, which was a distance of approximately one-and-a-quarter miles. This entrance has been partially sealed by the state, and is now the site of one of the largest bat hibernaculums in New Jersey.

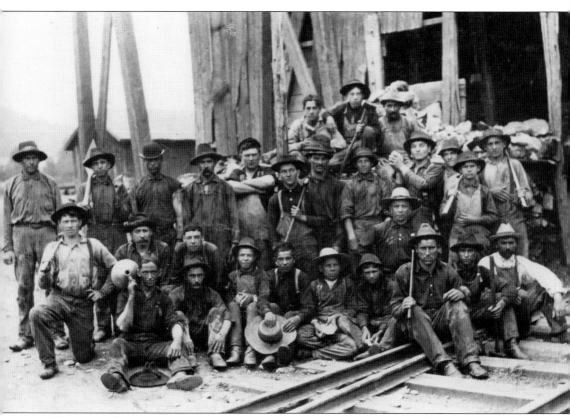

Work in and around the mines was strenuous and the hours were long. Male children as well as adults held jobs in an effort to supplement the family's income.

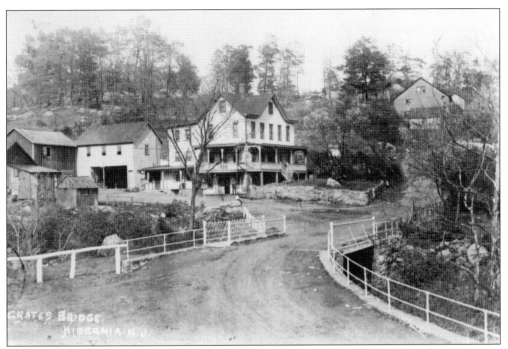

Located on Miggins Road in Hibernia, this complex of buildings consisted of the Bottling Shop with a shed attached, a stable, a wagon shed with a hall upstairs, and the Heslin Hotel. On the hill was Miggins Hotel, which was a boardinghouse and tavern. At one time, Miggins Road was the main road from Hibernia to Green Pond.

This was another Heslin home located opposite the Heslin Hotel. Behind this house was a building used for basketball games and dances. The 1916 minutes of the Basketball Association refer to this building as Heslin's Lyceum. Officers of the association were William Winters (president), Joe Machineshop (vice president), George Geisick (secretary), George Skewes (treasurer), and Francis P. Smith (team manager).

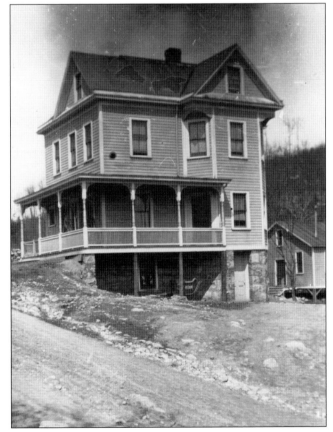

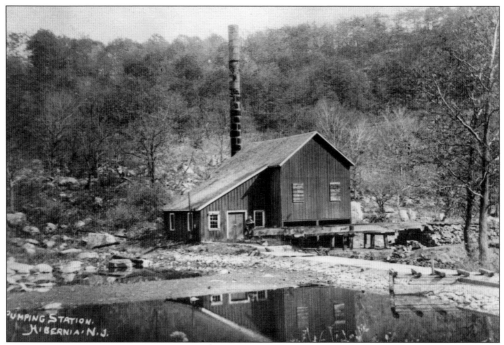

The pumping station was utilized to pump water up the mountain to the village of Upper Hibernia by means of a pipeline, which emptied the water into a man-made reservoir at the top of the mountain. This community did not have its own source of water.

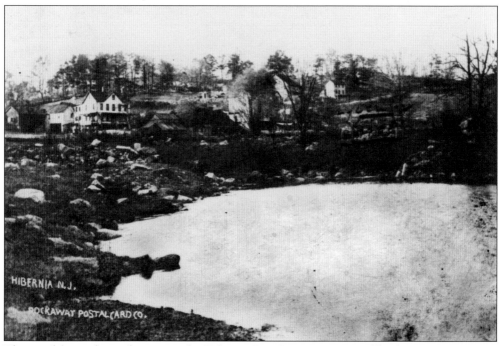

This pond, located near the present-day Hibernia Fire Company, was used by the pumping station. It was also the site of the 1765 Hibernia Furnace and a forge, built at a later date. On the left is another view of the Heslin Hotel on Miggins Road.

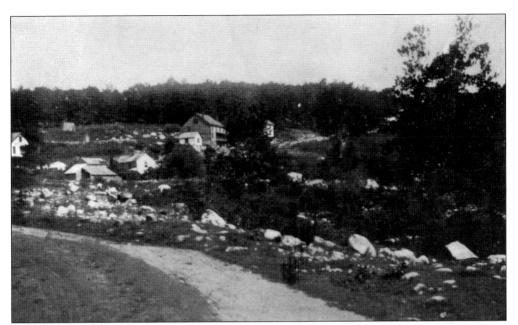

Here is another view of the furnace site. This furnace supplied the Continental Army with cannons, cannonballs, and other military supplies. It continued in operation until the early 1800s. In 1809, John Jacob Faesch placed an advertisement in the newspaper to sell the Hibernia Furnace and a tract containing about 5,000 acres of woodland and an iron ore mine.

The Delaney Family, in conjunction with the Heslins, operated a bottling operation known as the Heslin/Delaney Bottling Works. The Delaney house, located on Green Pond Road, is still in existence.

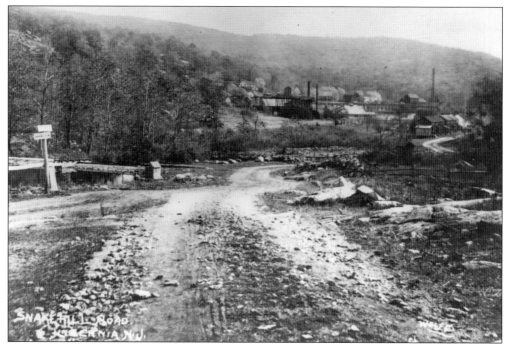

This view of Hibernia was taken from what is now present-day Snake Hill Road, which extends from Lake Denmark Road to Green Pond Road.

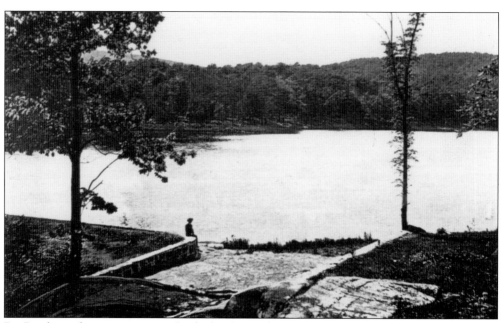

Big Pond was the name given to this body of water by the local residents, but more recently it is referred to on maps as Lake Ames. The name Lake Ames was derived from a Boy Scout camp known as Camp Ames, which was located across the lake to the left. In 1975, Rockaway Township purchased this 285-acre tract of land.

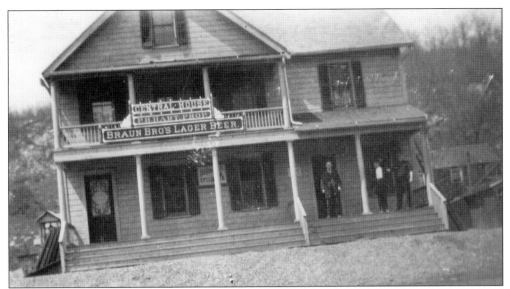

Around 1905, this inn known as The Central House was erected. The owner, Patrick Hart, hired George Crampton to build the hotel on this property, which once was the site of Appel's Grocery Store. At a time when local residents were using community wells, this building had a water reservoir on an upper floor. By pumping a handle, water was gravity-fed to other parts of the dwelling.

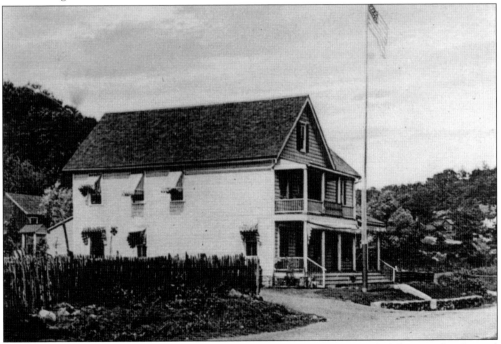

The Central House, also known as Hart's Tavern, stayed under the control of the Hart family until Walter Uebe purchased the building and changed the name to the Hat Rack Inn. Hats from all over the world were featured. In 1967, Richard Golden became the owner, and he changed the name to the Olde Hibernia Inn. Presently it is the restaurant Luzzi's Hibernia Inn, well known locally for its cuisine.

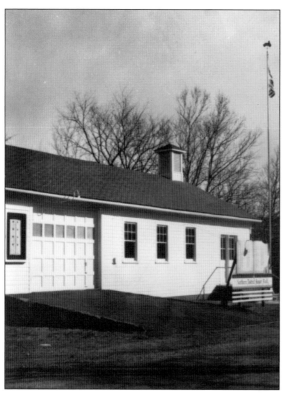

On May 30, 1935, a group of citizens met in Cuneo's Store in Hibernia and organized the Hibernia Fire Company No. 1. By September of the same year, plans were underway to build a 30-foot-by-50-foot building on property owned by the Warren Foundry and Pipe Company on Green Pond Road. The lumber from the old Lyonsville Public School was purchased and used to begin construction.

This is a 1923 picture of the Parliman Store, which was owned by Charles Parliman. The next owners were the Cuneo family. The store has changed owners several times and is presently known as Texas Smoke.

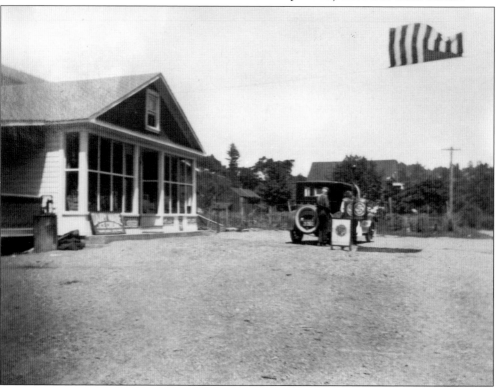

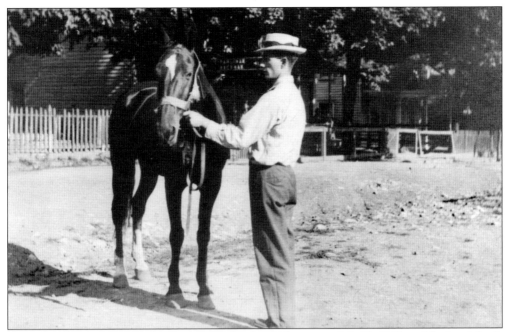

Harry Hiler, son of Sam and Catherine, was born in Hibernia on July 28, 1885, and died on March 18, 1986. Also known as "Uncle," he was known for playing the fiddle at Egbert's Lake square dances and for caring for horses that were owned by a local priest. In return, he was allowed to borrow a horse for social occasions.

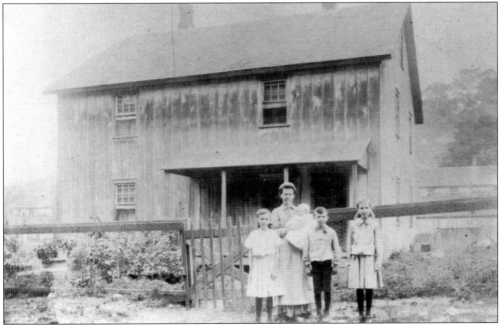

Shown in this 1911 photograph is the Flanigan family. Mother Margaret Flanigan is holding baby Lawrence, who was born May 3, 1910. Pictured standing are Johannah (left), Thomas, and Ann. Another sister stayed inside because she was camera-shy. This house still stands in the center of Hibernia on Green Pond Road.

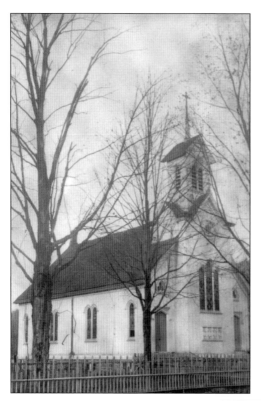

The Hibernia Methodist Episcopal Church was built in 1869 at the cost of $8,100. The Andover Iron Company; Richards, Beach, and Company; Richards and Tippets; the Honorable C. Beach; and others donated these funds. In 1901, extensive repairs and alterations were made. A new pressed-tin ceiling, pews, and gaslights were installed. Through the years, the congregation raised funds to support the church by hosting socials and dinners.

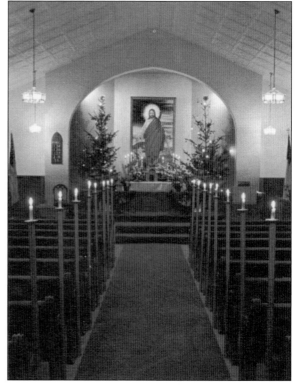

The Holy Trinity Lutheran Church congregation began using the building in 1948 and purchased it in 1952. The altar painting was done by a student, W. Nestoly, from Morris Hills High School, and the Olsen family donated the chandeliers in April 1958. In 1969, the Lions Club purchased the church and donated it to the town to be used as a library.

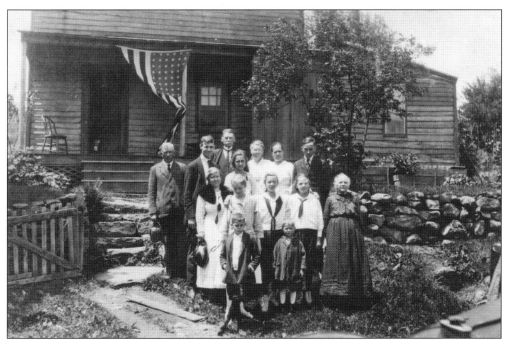

In 1920, this photograph was taken at the Shawger house. From left to right are (first row) two unidentified boys; (second row) Alice Chamberlain, Lenora Chamberlain, Hestor ?, Ellen ?, and Grandmother or Great-Grandmother Hester Shawger Hiler; (third row) Thomas Rhoda, Amos Chamberlain, Uncle George Hiler, unidentified, Grandmother Noral Hiler, Nellie Hiler (George's wife), and George Jr.

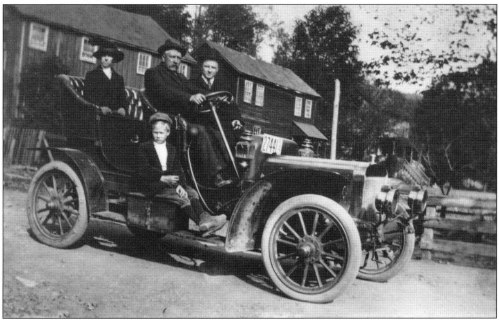

Pictured at the intersection of Upper Hibernia Road and Sunnyside is the Rhoda family car, which was a 1906 Jackson. The driver is Thomas Rhoda, and in the passenger seat is George Rhoda. Miners' homes can be seen in the background.

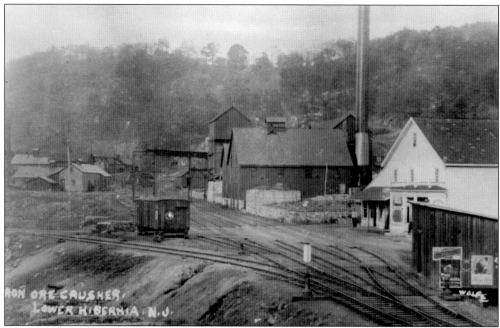

The crusher was located near the Hibernia General Store. Notice the large smokestacks and other mining buildings that were located to the rear and to the right of the crusher. The original construction date of the general store is unknown. An 1872 newspaper article listed it as Richards, Beach, and Company Store. In addition to shopping at the general store, some villagers kept cows, pigs, and chickens, and raised homegrown vegetables.

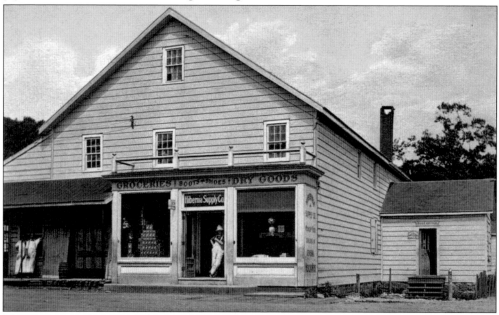

The store was subsequently known as the Hibernia Supply Company and later as the Hibernia General Store. As a mining company store it outfitted the workers and their families with clothing, furniture, food, and household supplies. An account book was kept for each family's purchases. At the end of the month, the total cost of the supplies was deducted from the miners' pay.

Eventually the store became a private enterprise. The last two owners were Abe Hoffman and John Yurecsko. In the 1970s, it ceased operations and was used solely as a warehouse. Fire partially destroyed the building in 1976, and eventually it was demolished. The post office, located on the right, was established on March 19, 1868. The mail was sent from Rockaway Borough via the Central Railroad of New Jersey.

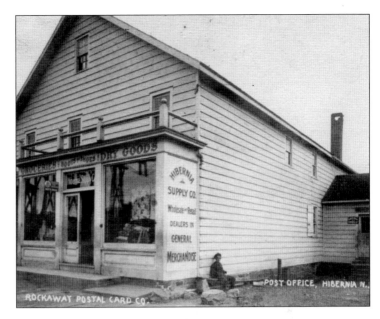

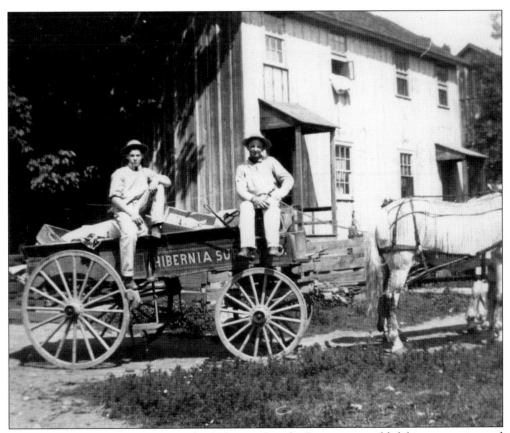

As a courtesy to their customers, the Hibernia Supply Company would deliver groceries and supplies to homes and businesses in the area.

The butcher shop, a busy enterprise in this lively village, was through the door to the left of the general store. Blocks of ice preserved a supply of fresh meats kept in the meat locker. More ice was kept in the icehouse behind the store.

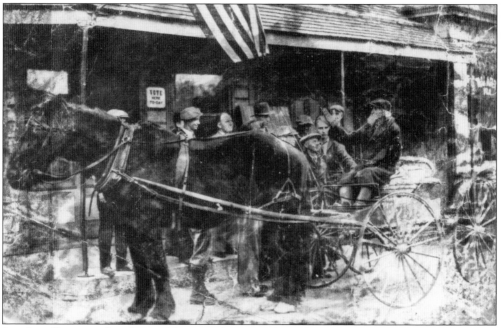

Besides selling merchandise and housing the post office, the general store was also the polling place as recently as 1932. At one time the store had the distinction of having one of the few telephones in the village of Hibernia. This picture shows Enos Zeek, a Marcella farmer, seated in his wagon arriving to cast his vote.

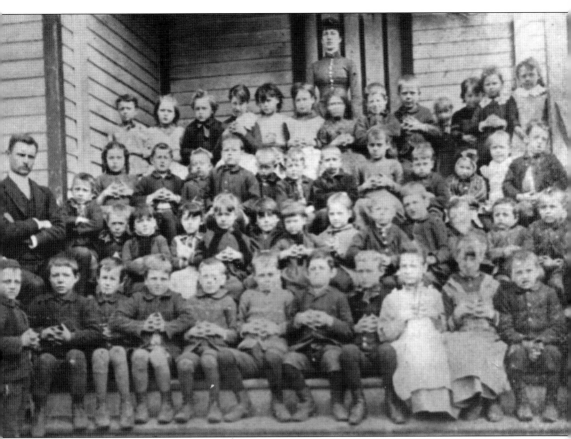

This picture was taken at the Lower Hibernia School in the spring of 1890. From left to right are (first row) Louis Stalter, Thomas Bush, Dan Ryan, George Rhoda, Albert Anderson, unidentified, Mike Mullen, Frank Barton, Hattie Hanschka, Lizzie Dempsey, James O'Dell, and Clara Spencer; (second row) Thomas Hulmes, unidentified, Alice Delaney, Annie Hillery, Alida Spencer, Mamie Delaney, Lizzie Spencer, ? Bostedo, ? Cook, Thomas Stalter, unidentified, and Raymond James; (third row) Hannah Dalrumple, Willie Ryan, George Allison, Joseph Cook, Warren Allison, Martin Parliman, Andrew Miggins, unidentified, unidentified, Emma Parliman, Annie Anderson, and John Williams; (fourth row) Julia Royal, Lizzie McNear, Rudolf Baxtrom, unidentified, unidentified, Theresa Cook, Lade Miggins, Thomas McCue, unidentified, unidentified, Nora Hillery, unidentified, and Lena Baxtrom. The male teacher on the left is Martin Con, and the female teacher in the rear is Fanny Reilly Jayne.

The original Lower Hibernia School was erected in 1880 at a cost of $5,000. This building had the modern convenience of steam heaters, but lacked indoor plumbing. Drinking water was obtained from the nearby brook, and outhouses were located nearby. In addition to a room called the office/library, there were two classrooms upstairs and two classrooms downstairs. In 1927 the building was destroyed by fire.

The 1921 eighth grade graduating class at the Lower Hibernia School is shown in this photograph. From left to right are (first row) Peggy McCullough, Ellen Grant, Angela Treverrow, Kate Yurecsko, Tess Kelly, Helen Kennyk, Tess Hart, and Ella Ryan; (second row) John Tatka, Sam Hoffman, Vincent Grant, Frank Smith (teacher), Earl Hulmes, Joseph (Bucky) Ryan, and Fred Winters.

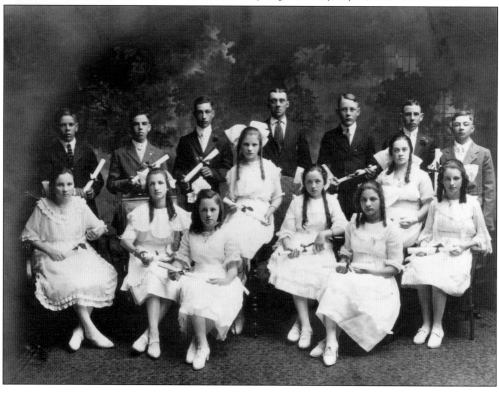

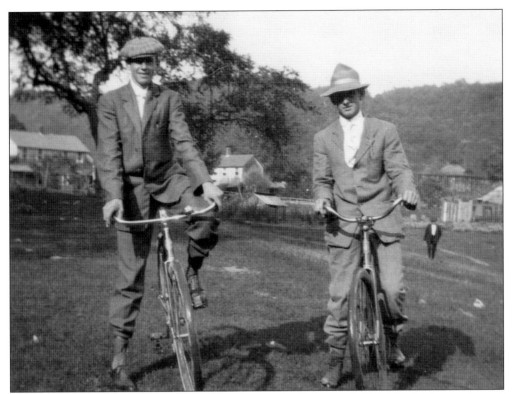

These two young men are out for a bike ride near the Hibernia ball field, which was situated between the Lower Hibernia School and the Methodist Episcopal Church. In the background to the left are the miners' homes. The trestle of the Hibernia Elevated Mine Railroad can be seen to the right.

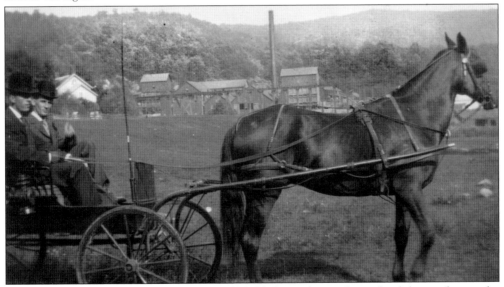

Another view taken from the Hibernia ball field shows the smokestack of the crusher in the background. Early entertainment included ball games, dances, picnics, singing in church festivals, weddings, and christenings. All were welcome.

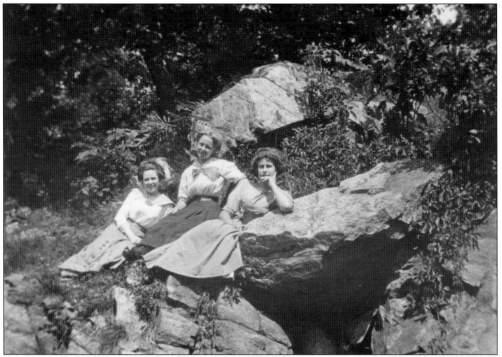

On the road that led from Lower Hibernia to Upper Hibernia, this rock, which was often called "the flat rock," provided a resting spot and picnic area. It was a favorite location for picture taking.

This photograph was taken on August 11, 1919, on the occasion of Aunt Hester's 80th birthday. Standing in front of the Rhoda/Chamberlain home in Sunnyside, Hibernia, from left to right are: Lenora Chamberlain, Alice Chamberlain (mother), Lenora Rhoda (grandmother), and Aunt Hester (Shawger) Hiler.

Lake Ames Boy Scout Camp was opened in 1929 and was named in honor of scoutmaster Joseph B. Ames, who died in 1928. It was active well into the 1940s, but was eventually closed. The 100 to 125 boys who came from the Morristown, Madison, Rockaway, and Rockaway Township areas enjoyed their time at this camp.

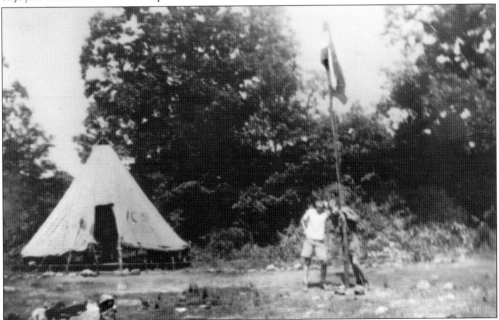

There were 11 cabins, a washhouse, a mess hall, a latrine, and living quarters for Mr. and Mrs. Christopher Pipher. Mr. Pipher, one of the first directors, organized the Morris County Boy Scouts Council in 1923 and served as its first executive. Another cabin was used as a first-aid station. From 1928 to 1933, Elsie Martin did the cooking at the camp.

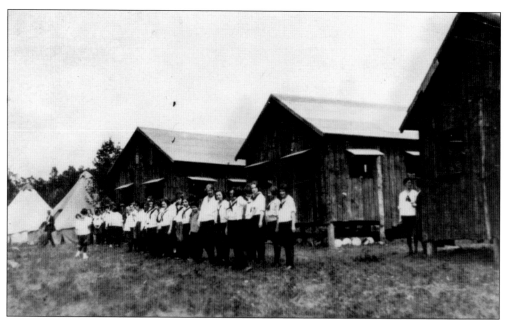

Camp McCoy was a Girl Scout camp in Hibernia that was named after a Mr. McCoy, who was from Hudson County. When a new director was appointed, the name of the camp was changed to Camp Hudsonia.

Senior Girl Scouts and their leaders utilized Wagner Cottage, located at Camp Hudsonia. It was believed to be the site of the Scott farm, where Katharine D. Malone School is now located.

The Girl Scouts contributed articles to the local newspaper about their varied activities, which included hiking, swimming, musical performances, skits, tournaments, and participation in the local baby parade in Hibernia. They headed the parade with their fife, drum, and bugle corps.

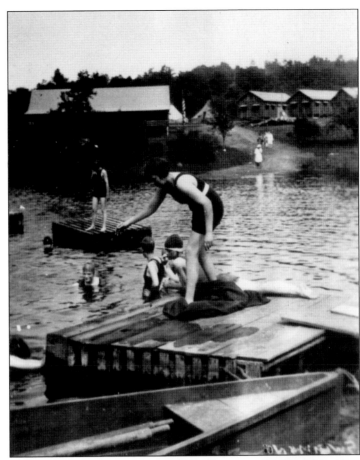

A family picnic in Meriden (near Split Rock) is depicted in this 1920 photograph. The center car was a 1919 Willys that belonged to George Rhoda, a resident of Hibernia. Standing next to the first car is Hester Ann (Shawger) Hiler.

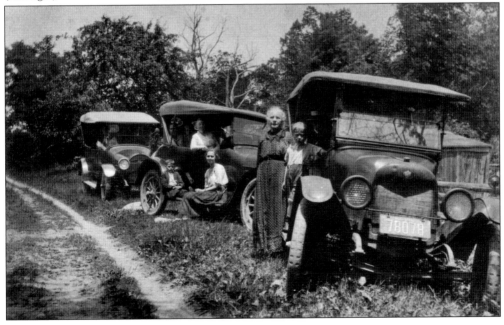

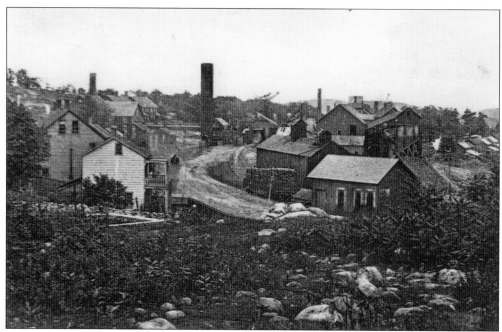

Members of the Kelly families on Kelly Row rented rooms to the men who worked in jobs related to the mining industry. The family would occupy the first floor, and the second floor was used as sleeping quarters for the boarders. The women of these households cooked and served meals for all occupants of the house.

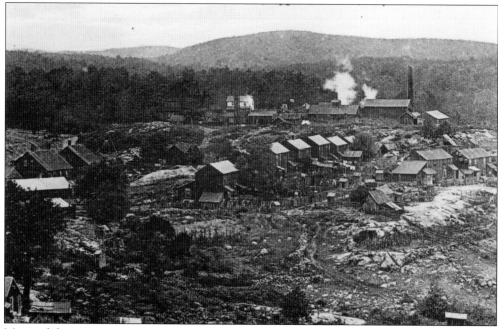

Many of the miners in Upper Hibernia lived in these two-family homes, which were rented from the mining company. Wood-burning stoves heated these homes, water was carried from a community well by buckets, and the bathroom facilities were outbuildings known as privies or outhouses. The larger house in the background was the home of the mine superintendent.

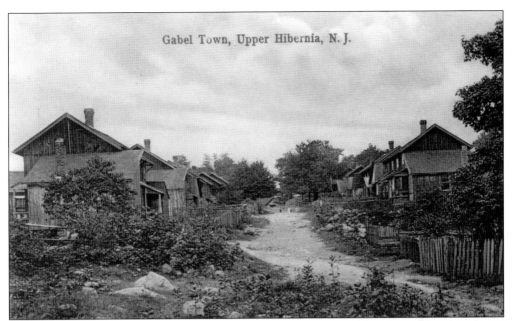

Gabel Town, Upper Hibernia, N. J.

In Gabbletown, Upper Hibernia, this narrow country road with buildings on each side to house the miners and their families was called a row. Other rows included Jordan Row, Black Row, York State, Chinatown, and Kuckletown.

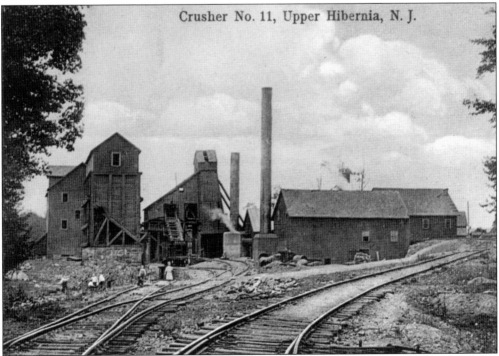

Crusher No. 11, Upper Hibernia, N. J.

Iron ore was placed on conveyor belts at Crusher No. 11. The machinery in the crusher was run by steam engines, and as the water circulated, it became hot. When the crusher was operating, hot water for household use could be obtained merely by taking a pail and filling it. Pictured here carrying water from the crusher is Andy and his sister Elsie Dudak and the family dog.

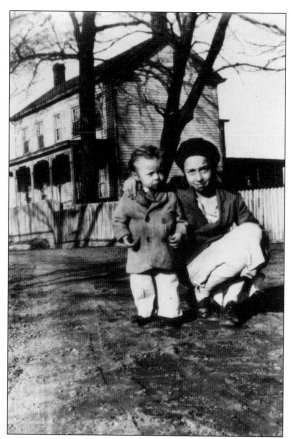

The superintendent of the mines generally occupied the best house in the neighborhood. After the mines closed, this superintendent's house in Upper Hibernia was privately owned. Pictured here are Elizabeth (right) and Andrew (Andy) Konecnic.

The Oreland School, also referred to as the Upper Hibernia School, was built before 1880. One very large room the width of the building was for the upper grades, one room was for the third and fourth grades, and one room was for the first and second grades. The remaining room on the second floor was reserved for live-in schoolteachers.

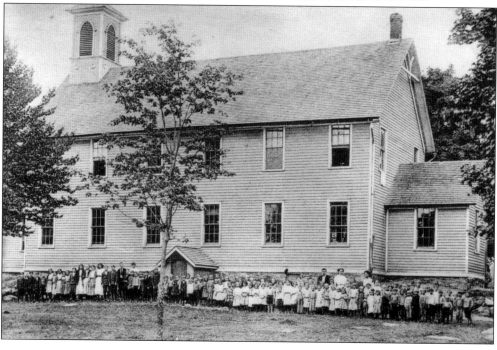

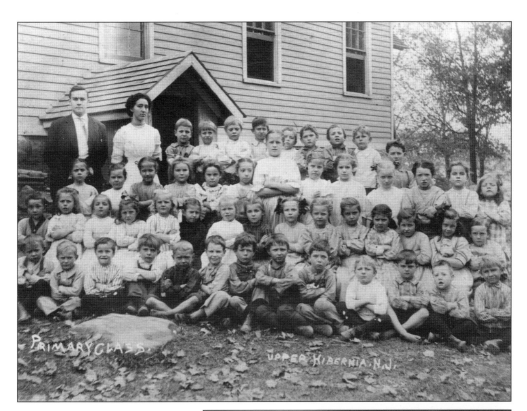

Pictured here with teachers Charles L. Curtis and Catherine M. Delaney are the first and second graders at the Oreland School in the fall of 1909. Some of the students shown are from the Colombo, Matthews, Polly, Kelly, Parcel, O'Melia, Yanovok, Williams, and Boyle families.

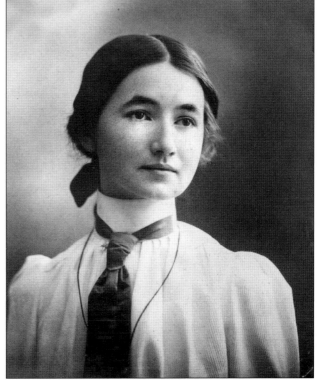

Katharine D. (Muldoon) Malone was 18 years old when this picture was taken. In 1904–1905, she taught the first and second grades at the Upper Hibernia Grammar School, where she had charge of 60 students. About 1906 she taught the second and third grades in the Lower Hibernia School. The Katharine D. Malone School was named in her honor.

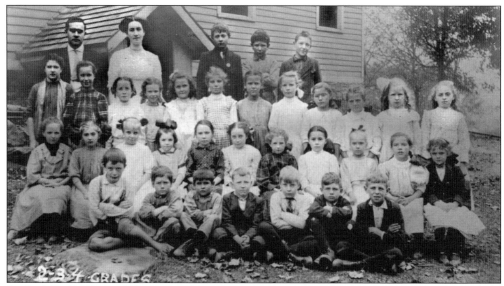

In the fall of 1909, the following students, pictured from left to right, were in the third and fourth grades at Oreland School: (first row) George Stalter, Sylvester Williams, John DeCoach, Peter Mason, David Matthews, Tom Kelley, and Andy Cline; (second row) Margaret Smith, Annie Gaydos, Lillian Zeek, Alice Caples, Liza McCullough, Mary Kearney (a twin), Martha Smith, Susie Parcel, Urania Zeek, Elsie Dudock, and Johanna Ryan; (third row) unidentified, Mary Polly, Katie Kearney (other twin), ? Miners, Lillian Kelley (mother of Gerald Green), ? Kukla, unidentified, Hilda Allison, unidentified, Mary Kennyk, Jennie Mulhern, and Margaret Mahalaga.

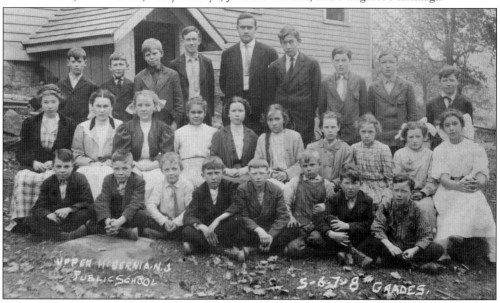

Pictured here are students at Oreland School in the fall of 1909. From left to right are (first row) Michael Ryan, Joe Caples, Ed Ryan, Ed Kelley, Hugh Mason, Paul Yurick, Tim Kelley, and Sylvester Kearney; (second row) Hattie Crum, Rose Quinn, Jennie Quinn, Rose DeCoach, May McCullough, Helen Parcel, Margaret Miners, Elizabeth Parcel, Edna O'Melia, and Mary Gaydos; (third row) John Hart, Tom Kelly, William Cline, Matthew Kearney, C. L. Curtis, Andrew Gaydos, Tom Kearney, Eugene Donohue, and John "Buster" Kelly.

Table 1.1

<u>1 8 9 5</u>

<u>ROCKAWAY TOWNSHIP SCHOOL BUILDINGS</u>

Schools in Service	Classrooms	Value	No. of Children
Lower Hibernia	4	$ 6,500.00	180
Hibernia	3	3,500.00	160
Mt. Hope	4	5,000.00	144
Mt. Pleasant	3	3,000.00	214
Union	1	1,000.00	54
Denville	1	400.00	56
Rockaway Valley	1	1,000.00	46
Beach Glen	1	1,000.00	30
Lyonsville	1	800.00	34
Marcella	1	1,200.00	64
10 Buildings	20	$ 23,400.00	982

SOME STATISTICS:

16 Teachers were employed; average salary for a male was $61.66, and for a female, $42.50 per month.

There were 61.4 children for every teacher, and 49.1 children for every classroom.

Information on the schools in Rockaway Township in 1895 is listed on this page.

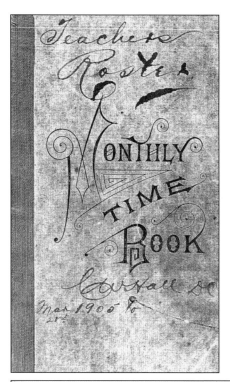

Teacher Roster Monthly Time Book CR Hall S Mar 1905 to 25th

This monthly time book records the salaries of some of the teachers and principals in 1905 and 1906. Notice the entry for Katharine Muldoon, whose married name was Katharine D. Malone.

| NAMES | Sept. 1 2 3 4 | Oct. 20th 5 6 7 8 9 | Nov. 10 11 12 13 14 | | Remarks | Total Time | Rate | Amount |
|---|---|---|---|---|---|---|---|
| *Supt* | | | | | School opened Sept 4th | | | |
| D. B. O'Brien | 75 00 | 75 00 | 75 00 | | Tuesday 1906. | | | |
| Jas. D. Loomis | 59 50 | 70 00 | | | Levengood resigned | | | |
| Daisy Wiggins | 45 00 | 45 00 | | | Nov 2nd 1906. 3 days due | | | |
| Katharine D. Muldoon | 45 00 | 45 00 | | | him at 60.— | | | |
| Mary J. O'Connell | 40 00 | 40 00 | | | | | | |
| Francis P. Smith | 55 00 | 55 00 | | | Thompson resigned Nov | | | |
| Anna M. Younkin | 45 00 | 45 00 | | | 9th 2 wks due & pd. | | | |
| Anna Horn | 40 00 | 40 00 | | | | | | |
| H. J. Levengood | 60 00 | 60 00 +9. Resigned | | | R. A. Fiske began as Prin at | | | |
| Miss J. Shaw | 47 50 | 47 50 | | | No 3 on Nov 5th 1906. | | | |
| Mary Flanagan | 45 00 | 45 00 | | | | | | |
| D. C. Thompson | 55 00 | 55 00 | Resigned 27.50 | | Herbert Dargue com— | | | |
| Alice A. Grady | 40 00 | 40 00 | | | menced at #4 on Nov 2-06. | | | |
| Margaret Dickison | 50 00 | 50 00 | | | | | | |
| Augusta Adams | 40 00 | 40 00 | | | Increase for Mr Gris— | | | |
| Louise J. Gravenstetter | 45 00 | 45 00 | | | wold took effect the | | | |
| E. L. Westbrooke | 50 00 | 50 00 | | | beginning of 3d month | | | |
| Edith McGrath | 40 00 | 40 00 | | | nov 06. | | | |
| Gunner Vought | 50 00 | 50 00 | | | | | | |
| J. S. Griswold | 50 00 | 50 00 2 Ryrats | 55 00 | | | | | |
| | $977 00 | 987 50 | | | | | | |

Time Book for the Month of 1906 + 07, 1906

Sept. Oct. Nov. Dec. Jan. Feb. Mch. Apr.

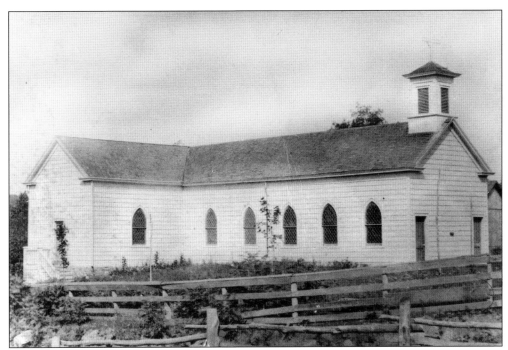

St. Patrick's Church was constructed in 1848 in Boonton as Our Lady of Mount Carmel Church. In 1865, it was dismantled and transported to Upper Hibernia, where it was rebuilt. Later, it was enlarged to serve the growing number of Catholics who worked in the mines. Seating capacity was about 100. Local priests performed services. The church burned to the ground on July 24, 1910, and was never rebuilt.

Angela Trevarrow's grandfather, a resident of Upper Hibernia, designed and made this archway at the entrance to St. Patrick's Cemetery, which was established in 1865. Many of the 120 individuals buried here are of Irish, Hungarian, and Slovakian descent. Some of the gravesites were not marked by family members because of the expense of such a marker.

61

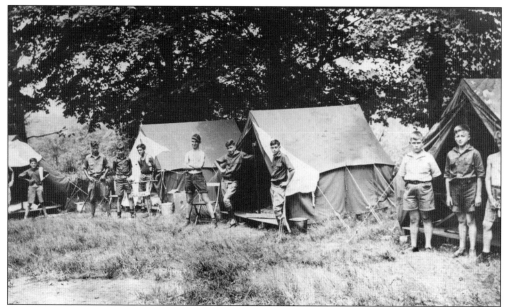

About 1933, Fr. Joseph Hewetson personally bought 10 acres of land in Upper Hibernia, which he donated to the St. Cecilia's Parish to be used as a Boy Scout camp. About 75 boys could be accommodated at the camp for several periods of two weeks during the summer months. This picture was taken at Camp Saint Cecilia in 1937.

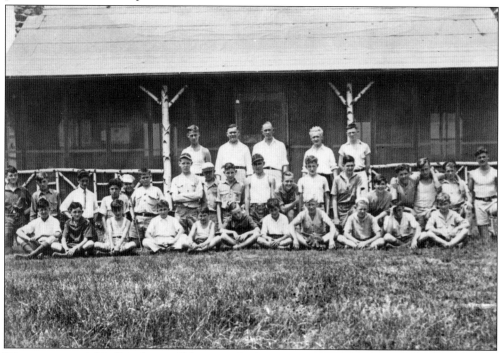

There was a social hall in Lower Hibernia, which was in a state of disrepair. The building was dismantled and the lumber was used to build the mess hall at the camp. Boy Scout Troop No. 23 is shown with their leaders in front of that building. A Mr. Rodimer was the drillmaster, and Elsie Martin did the cooking for the camp.

Three

BEACH GLEN, MERIDEN, LYONSVILLE, AND SPLIT ROCK

These areas of the township were populated by people performing a variety of jobs. In addition to farmers and miners, some people earned a living working in the forge and furnace operations. There were two forges at Beach Glen, previously known as John Johnston's Iron Works. Later it was known as Horse Pound (1765), then as Horse Pond (1781–1790), and eventually as Beach Glen. There were also two forges at Meriden.

Located in Lyonsville was the Split Rock Furnace Complex, which consisted of a blast furnace, ore roasting kiln, a forge, workers' houses, and a company store. The Split Rock Furnace, built in 1862 by Andrew Bell Cobb, is listed on the State and National Registers of Historic Sites.

Although Lyonsville was hilly, local farms had existed since the 1700s, and as the nearby iron industry prospered, these farms supplied food for the fast-growing mining communities. Lyonsville landowners raised much-needed livestock and farm products. In 1880, the population of Beach Glen was 195; Meriden, 99; Lyonsville, 141. Many of the early settlers' homes still exist and have been remodeled and modernized.

Also located in this area is Split Rock Reservoir. In 1947–1948, a new dam was constructed that expanded the original Split Rock Pond to form a 640-acre reservoir. As part of the Jersey City Water Supply System, the main purpose of the reservoir was to release water into their reservoir at Boonton during periods of drought.

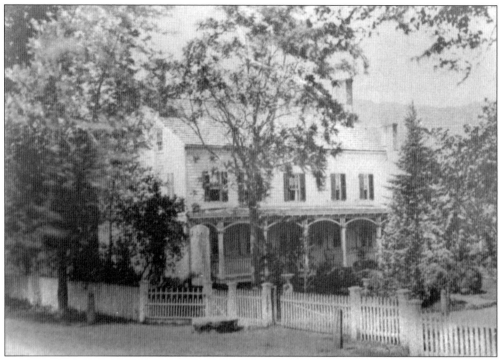

The Beach Family, owners of the Beach Glen Mines, built their homestead on the crest of the knoll overlooking their mine property. It was opposite of what is now Metro Supply, and was supposedly the first house in the area with a tin bathtub.

Benjamin Beach and his second wife, Nancy Searing, had two sons, Chilion and Samuel S., who inherited the Beach Glen property. Chilion, pictured here, was born in 1792, and married Cornelia DeCamp in 1814. When she died in 1832, he married his second wife, Catharine Hartwell, in 1834. Chilion died in 1883.

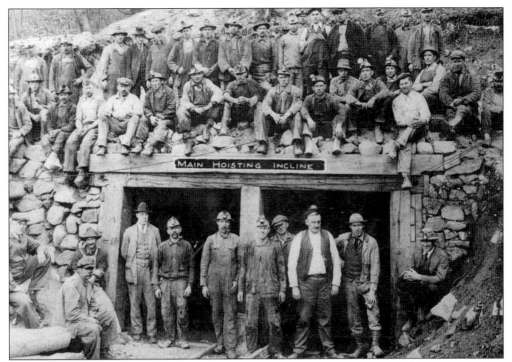

The earliest recorded mining operations at Beach Glen were in 1808. Over the next 100 years, the mine was closed and reopened many times. By 1930, the mine closed permanently. Shown here is the day shift during the 1920s.

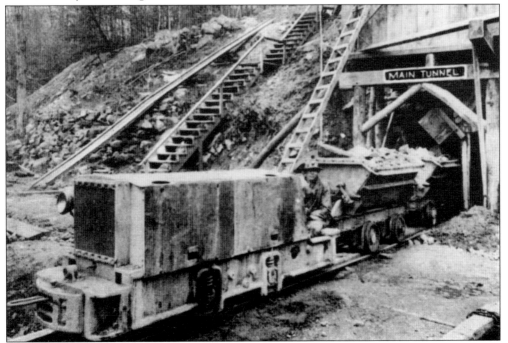

From 1920 to 1923, North Jersey Steel Company operated the mine. This photograph shows an electric locomotive hauling cars loaded with iron ore out of the mine.

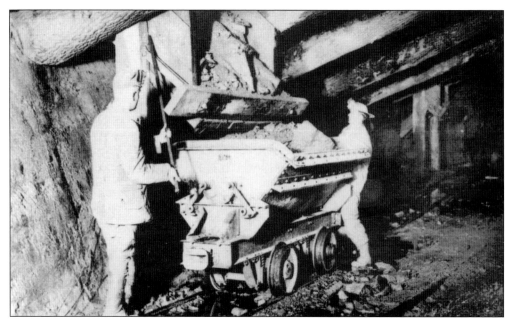

This was a publicity shot taken in the 1920s to illustrate how the company had made the operations more mechanized and efficient. A similar, six-ton capacity ore car, once used in the Beach Glen Mine, is presently on display in front of the Rockaway Township Municipal Building. Pictured are Joseph Tatka (left) and Martin Konecnic Sr.

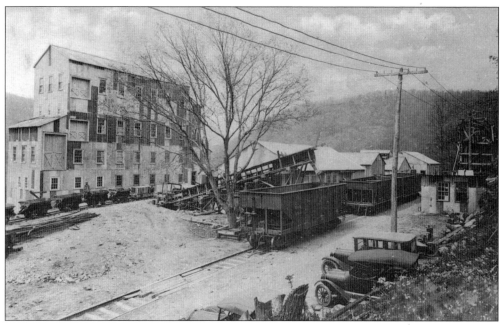

In the 1920s, a surface plant was located at the Beach Glen Mine. After being processed by the crusher, the iron ore was loaded into the waiting hopper cars and transported to Rockaway Borough on the railroad that paralleled Green Pond Road.

The foundation of the Beach Glen School is still visible behind the fence of the former Hewlett-Packard Company property, which is currently owned by Christ Church. Although both boys and girls are seen in this school picture, the majority of the boys left before graduating to take jobs to help support their families. In 1881, the average salary for a teacher was $35 a month.

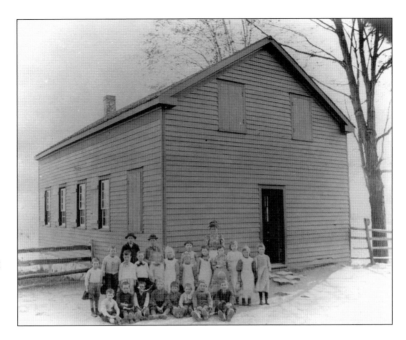

During his career, William VanWinkle taught school at Greenville, Lyonsville, and Beach Glen. He also operated a gristmill and a sawmill in Rockaway. He died in 1938 at the age of 96. This voucher is made out to him for the amount of $40.90 for repairs, painting, and coal for the Beach Glen School.

The Slovak Catholic Sokol is an athletic and gymnastic society. The training of American Slovak youth to be loyal American citizens and devout members of the Catholic Church was the aim of the organization. It was founded in Passaic on July 4, 1905, and held a convention in Hibernia in 1906.

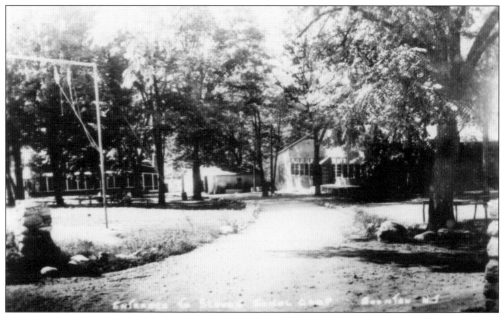

A 35-acre camp for these young athletes was located on Old Beach Glen Road in Rockaway Township. Activities included swimming in the lake, tennis, ice-skating, and ice carnivals. In the 1950s, gymnastic and calisthenics exhibitions and track and field meets were held in which hundreds of young people competed. New homes now occupy this site.

In 1792 Abraham Crane built this house. Because it was the largest home in Lyonsville, it was known as the Mansion House. A log cabin that was the original dwelling of Abraham Crane had been constructed on the property in 1758. The property remained in the Crane family and their descendants (the Shaws and Earles) until about 1940, when it was purchased by the Earl Wallace family.

James and Susanna Lyon were among the original settlers in this area. The center portion of the house was built in 1804, and additions were made at later dates. The Lyon family operated this 100-acre farm. In 1862, a blacksmith shop was constructed. Around 1868, the property was sold to the Looker family, who worked it as a cattle farm. In 1944, it was sold to Thomas Oakes.

Daniel Lyon, son of James Lyon, was born on July 24, 1808, and died in 1898. He married Catherine Ann Earle on May 19, 1838, and they had six children. He built a house prior to 1840 at the intersection of Split Rock and Lyonsville Roads. Daniel's grandson, George, lived in the house until his death in 1935. His widow sold the home to Cyrus Falconer in 1949.

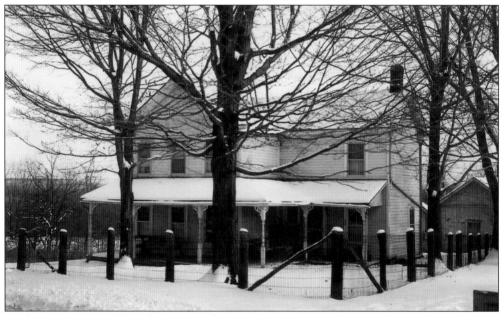

Andrew Lyon, son of Daniel Lyon, was born on January 18, 1848. He built this home in 1876, and additions were made to the house in 1897. He married Minerva Hiler in September 1943. Their children were Stanley (wife Cora Milburn), Reta (wife of Leo Hart), and Grace (wife of Joseph Concialdi). Andrew died in September 1943. His daughter, Reta (Lyon) Hart, lived in the house after his death.

This one-room schoolhouse in Lyonsville was built around 1879. In 1895, it had 34 students who were taught by one teacher. The building was purchased in 1935, and the wood was removed and used to erect the Hibernia Firehouse.

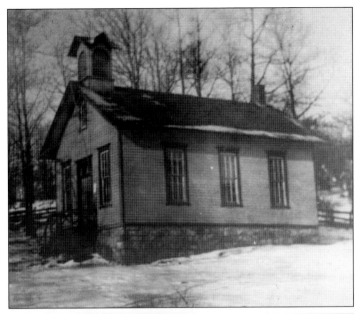

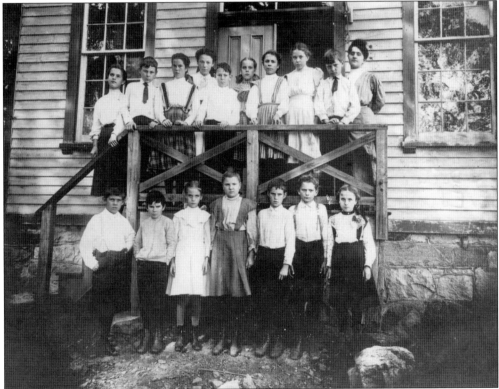

Students who attended the Lyonsville School are, from left to right, (first row) Lester Eakley, Cheever Shaw, Flora (Earles) Schmitz, Marion Shaw, George Decker, Rufus Smith, and Lillian Russell; (second row) Evelyn (Corby) Newman, Ogden Towell, Edith (Shaw) Kimble, Mabel Towell, Robert Towell, Ethel (Earles) Morgan, Edna Shaw, Nellie Decker, John Shaw, and teacher Louise Gramenstetter.

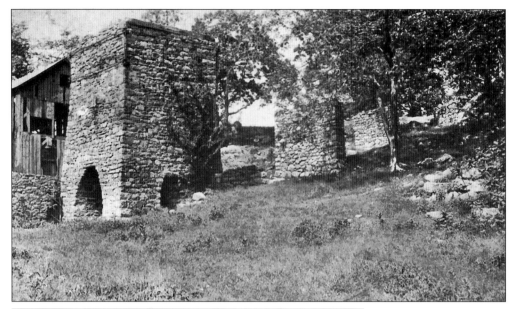

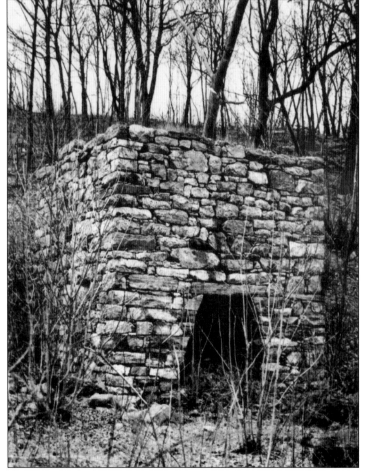

Besides the blast or smelting furnace at Split Rock, there was an ore roasting kiln and a crushing mill. In this remote area, the furnace and the remaining ruins of foundations of houses and outbuildings are evidence of what was once a thriving industrial community. The furnace, the last of its kind built in Morris County, represents the end of the era of the charcoal furnaces.

The function of the ore roaster was to remove some of the impurities from the iron ore before it went into the blast furnace.

On November 10, 1948, dedication ceremonies were held for the newly opened Split Rock Reservoir. The 3,000-MG (million gallon) capacity storage reservoir was created for backup gallonage for the Boonton Reservoir, which serves Jersey City. (Courtesy of Ronald Shea.)

CITY OF JERSEY CITY

❧❦

DEDICATION OF
SPLIT ROCK RESERVOIR

ROCKAWAY TOWNSHIP

MORRIS COUNTY

❧❦

NOVEMBER 10, 1948

Teams of workers cleared 640 acres of land from 1947 to 1948. The "Hibernians," as they were known, are seen here on a blustery winter day burning the remaining stumps. (Courtesy of Ronald Shea.)

William H. Krum, foreman of the Split Rock Reservoir project, stands proudly on a rock outcropping that would later be submerged to a depth of 40 feet. Of Lenape descent, his ancestors would have hunted and fished at Split Rock Pond, which was enlarged to form the reservoir. (Courtesy of Ronald Shea.)

Inspecting a large, solitary boulder is one of William H. Krum's dogs. This boulder and many others were never removed and are now at the bottom of the reservoir. (Courtesy of Ronald Shea.)

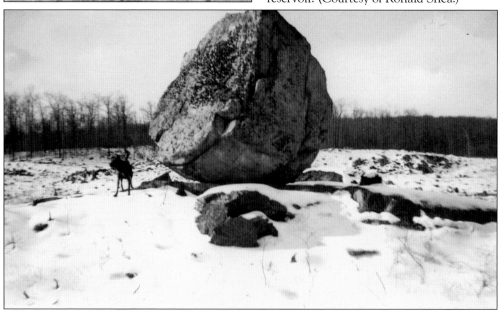

Four

MARCELLA

The Marcella section of the township was at one time called Greenville. Mail service became poor when it was confused with another Greenville in New Jersey. William H. Marshall, who operated the post office in his store, thought it best to change the name of the community so that mail service would improve. Marshallsville was proposed but was declined in favor of the name Marcella.

Many of the early settlers in this area of the township were farmers. Other local small businesses included a blacksmith shop, forges, and low-yielding iron ore mines. Family names such as Allison, Bostedo, Clark, Matthews, Egbert, Earles, Marshall, Munn, Shaw, Winters, and Zeek can be seen on tombstones in the various township cemeteries. There are descendents of some of the early settlers still living locally, and some of the original homes are still in existence.

The Marcella Union Cemetery, the only active cemetery in Rockaway Township, was started in 1902 on land donated by John and Elizabeth Egbert. The nearby Marcella Chapel was built in 1903.

The Greenville Mines were located off Upper Hibernia Road. In 1873 they were explored for potential development, but due to the inferior ore quality and wetland topography they were never mined.

The Egberts were a prominent family in Marcella. In the 1920s, they decided to create a lake as a focal point for a vacation community for their family. Outdoor activities, celebrations, and reunions were enjoyed. Eventually, the Egbert Resort Company was incorporated and the grounds were opened to the public for camping, picnicking, and swimming.

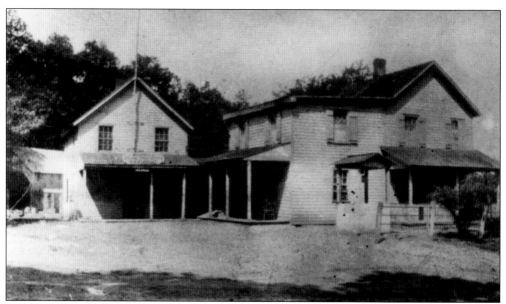

Marshall's store and post office was believed to have been in operation in 1895 and might possibly be older. William H. Marshall's dairy cows provided cream from which he made homemade ice cream for his customers. He moved a building from the vicinity of the Circle S Ranch to enlarge his business. This enterprise was closed permanently about 1917, and is now a private home owned by his grandson.

Peter Henderson Sr. built this house around 1834. In 1880, the property was sold to Harriet Munn and remained in the Munn and Egbert families from 1880 until 1919, when it was acquired by Samuel and Almira Lanning. Attaching a building moved from Miggins Road in Hibernia enlarged the house. Another addition was constructed for a candy store. In the 1960s, Bertha McGuire bought the property and operated an antique shop.

It is thought that Peter Henderson Jr. erected this house in 1851. In 1880, the land was deeded to Charles and Julia (Henderson) Egbert. The property passed on to Owen and Catherine Lynch in 1895, and then to Losey and Alice (Stalter) Henderson in 1900. In 1925 when Losey died, the house was deeded to his daughter, Eva Dougherty.

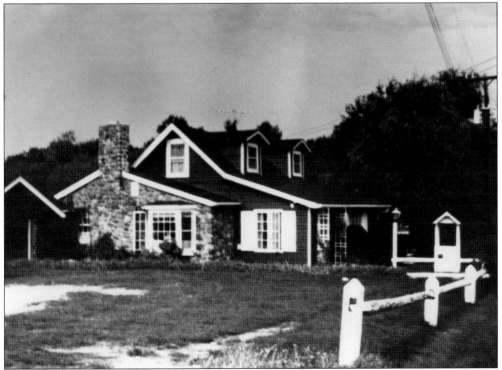

In 1939, Robert Enholm Sr. and his wife Clair purchased and renovated the house shown at the top of this page. They were responsible for completing the Green Pond Golf Course, which had been started earlier on the property adjacent to their home. This house no longer exists.

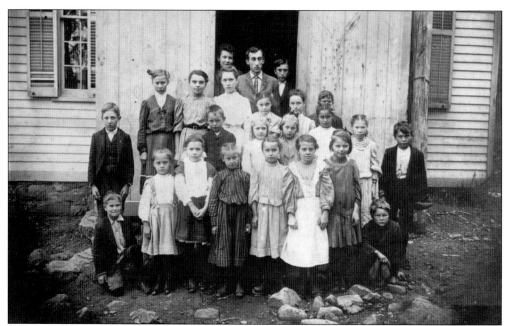

The first Marcella Grammar School, which was built about 1826, was located on Timberbrook Road. Years later it was damaged by fire and was rebuilt in 1843. First through eighth grades were all taught by one teacher in this one-room country schoolhouse.

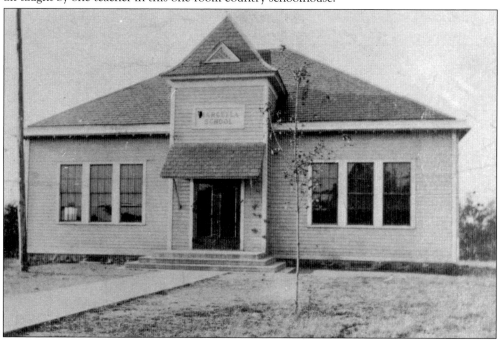

The wood-framed Marcella School was completed in 1915 at a cost of $3,250. It contained two rooms with a seating capacity of 40 students in each room. During World War II, the Catholic Church used this building. In 1953, the Marcella Fire Company built an addition to house equipment. From 1954 until 1966 a cloakroom served as a public library. It is now owned and operated by the Marcella Community Center.

Many current Marcella residents are descendants of the students listed on this page from the Marcella School 1909–1910 souvenir yearbook. Teacher Bion L. Thomas taught all grades while Dennis B. O'Brien served as the supervising principal. (Courtesy of Marcia and Mark Schiffer.)

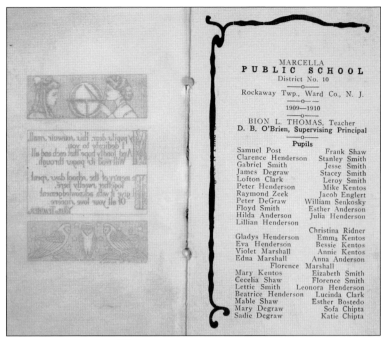

MARCELLA
P U B L I C S C H O O L
District No. 10
Rockaway Twp., Ward Co., N. J.

1909—1910

BION L. THOMAS, Teacher
D. B. O'Brien, Supervising Principal

Pupils

Samuel Post
Clarence Henderson
Gabriel Smith
James Degraw
Lofton Clark
Peter Henderson
Raymond Zeek
Peter DeGraw
Floyd Smith
Hilda Anderson
Lillian Henderson

Gladys Henderson
Eva Henderson
Violet Marshall
Edna Marshall
Florence Marshall
Mary Kentos
Cecelia Shaw
Lettie Smith
Beatrice Henderson
Mable Shaw
Mary Degraw
Sadie Degraw

Frank Shaw
Stanley Smith
Jesse Smith
Stacey Smith
Leroy Smith
Mike Kentos
Jacob Englert
William Senkosky
Esther Anderson
Julia Henderson

Christina Ridner
Emma Kentos
Bessie Kentos
Annie Kentos
Anna Anderson

Eizabeth Smith
Florence Smith
Leonora Henderson
Lucinda Clark
Esther Bostedo
Sofa Chipta
Katie Chipta

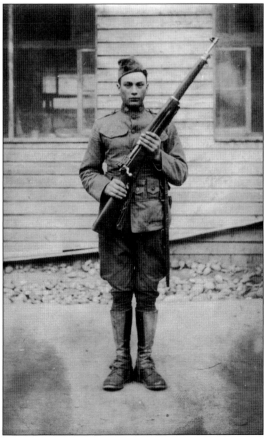

On August 8, 1918, the *Advance* newspaper headline read: "158 Men Examined by Local Board. 100 of Them Found Physically Fit on Tuesday." Gabriel Frank Smith was among them. Private Smith, posing here in his World War I "doughboy" uniform, attended the Marcella School as a youth. "Gabe" was honorably discharged after the war. He returned to live in Marcella, where he worked at Picatinny Arsenal and served as a Rockaway Township councilman. (Courtesy of Ecla Wellington.)

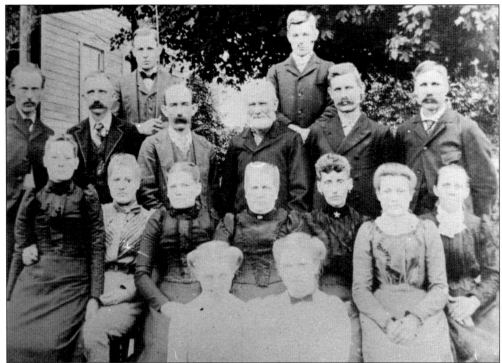

The Egbert family gathered for a family picture at their homestead *c.* 1895. Pictured from left to right are (first row) Inez Egbert and Vanessa Egbert; (second row) Jane E. Hiller, Eva Lena E. Shaw, Bertha E. Beach, Elizabeth (Allison) Egbert, Hannah E. (Zeek) Egbert, Lillie Egbert, and Martha M. (Marshall) Egbert; (third row) Halsey M. Hiller, Andrew J. Shaw, Cyrus T. Beach, John Egbert, John A. Egbert, and Amida B. Egbert; (fourth row) Harry E. and Melvin C. Egbert.

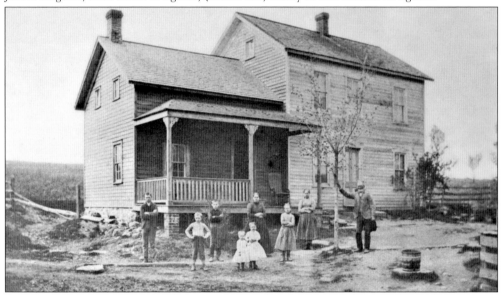

Andrew Bell Cobb erected this house around 1865. John and Elizabeth (Allison) Egbert lived here after they moved from Green Pond to Marcella. The last 11 of their 13 children were born in this house. At the age of 68, John died at this family homestead.

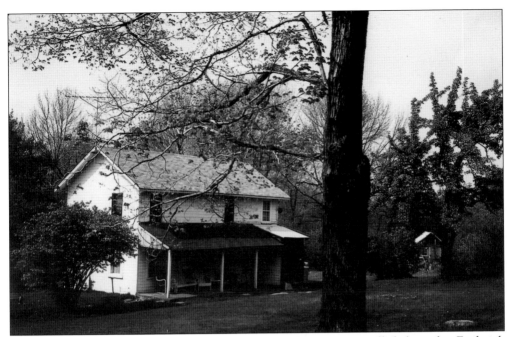

This property, which appears on the 1887 *Robinson's Atlas* map, originally belonged to Frederick and Caroline (Allison) Matthews, and was then passed down through the family to Cornelia (Matthews) Norman and her husband Ansoleum, to Jane M. (Norman) Egbert and her husband Harry E., and lastly to their daughter, Thelma M. (Egbert) Rickley and her husband John.

Hannah Saunders, who married a Holloway, occupied this house on Jacob Road. These early settlers, who were farmers, left this house to their son, Clarence. Clarence and his mother, Hannah, are buried in the Marcella Union Cemetery.

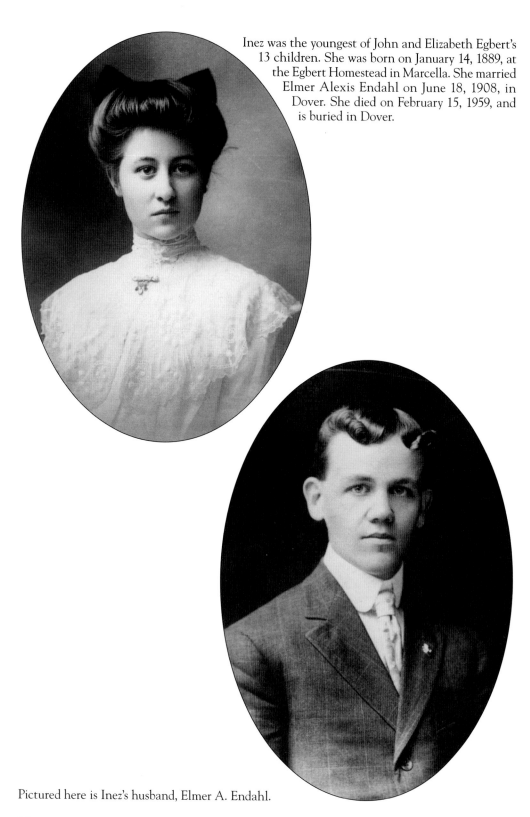

Inez was the youngest of John and Elizabeth Egbert's 13 children. She was born on January 14, 1889, at the Egbert Homestead in Marcella. She married Elmer Alexis Endahl on June 18, 1908, in Dover. She died on February 15, 1959, and is buried in Dover.

Pictured here is Inez's husband, Elmer A. Endahl.

The Egbert family created this lake in 1928 by damming a nearby spring and flooding the existing meadow. The area was then used as a private lake and resort for the Egbert family. Later it became a popular summer entertainment place, providing square dancing and weekend entertainment. Once it was opened to the public, it offered camping, picnicking, and swimming. Presently it is a Rockaway Township park known as Egbert's Lake Park.

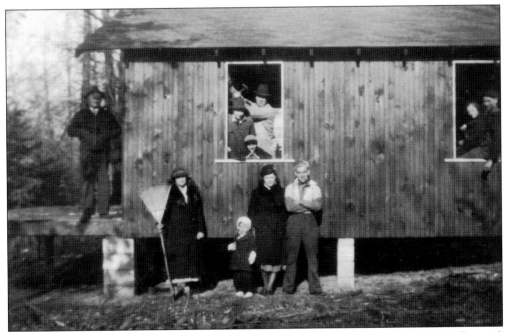

This 1933 photograph shows the bungalow of Leslie O. Egbert and his wife, Hilma K. (Larson) Egbert. Pictured in front of the bungalow from left to right are Hilma Egbert, Barbara E. James, Ida E. (Egbert) James, and Kenneth E. James; on the porch is Melvin C. Egbert; in the left window are unidentified, Howard L. Egbert, and Wally Drexel; in the right window are Joyce L. Egbert and Leon O. Egbert.

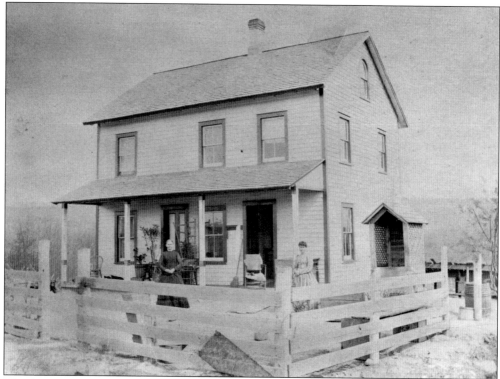

This home on the corner of Green Pond and Henderson Roads was possibly built around 1850. Shown in the photograph, which was taken in the 1890s, is Mrs. Albert Miller. Daniel E. Snyder and his wife, Amelia, were known to be in possession of the house in 1939.

The William J. Henderson House was erected about 1913 from materials recycled from the Copperas Mine Boardinghouse. William Henderson died in this house in 1939. He was the son of William Barton and Rachel (Allison) Henderson. The house is near the original William Barton homestead. Lt. William Barton fought in the Revolutionary War and is buried in the Zeek Cemetery. He was the maternal great-grandfather of William J. Henderson.

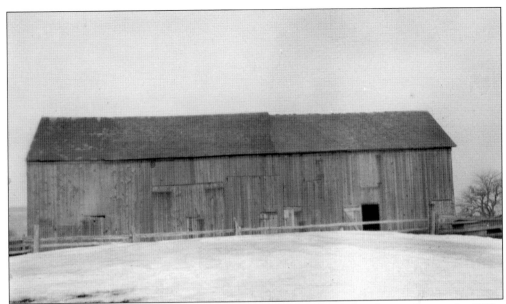

This photograph of the barn located on the Earles farm on Jacob Road was taken in the 1930s. In the 1840s, the original barn was built using chestnut lumber. An addition was constructed in the 1870s. Deeds indicate former owners were the Bartons, Cobbs, and Earles. The barn is still standing and is owned by the Will family. (Courtesy of the Will family.)

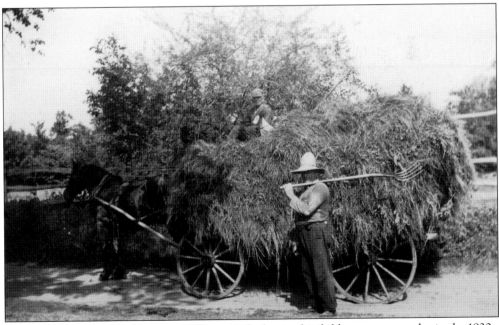

Shown in this photograph is farmer Warren Earles haying his fields on a summer day in the 1930s. He died in 1963 when he was 83 years old. (Courtesy of the Will family.)

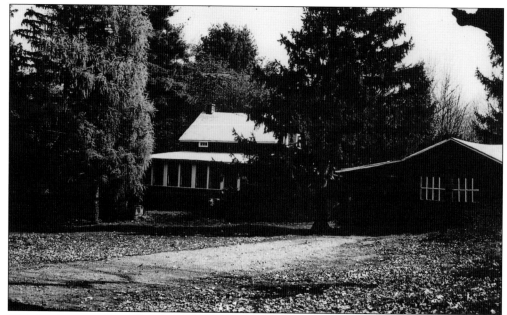

This farmhouse on Jacob Road was the home of one of the early settlers in Marcella. John Allison moved to his house with his wife Jane (Davenport) around 1842 with their eight children. Five more children were born in this house. John built the Davenport Hotel in the early 1840s at Green Pond. He died in 1874, and Jane died in 1890. They were both interred in the Marcella Union Cemetery.

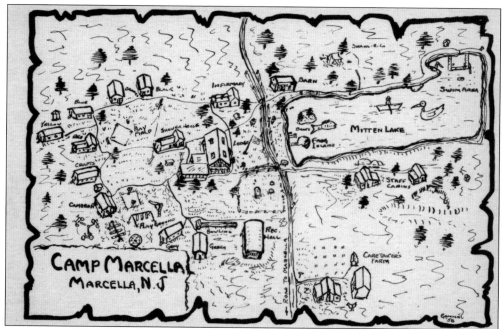

Camp Marcella is a 200-acre camp run by the Lions Club. The property was part of a farm owned by the Zeek family. The camp accommodates blind and visually impaired children between the ages of 6–18. In operation since 1948, it offers children a camp experience at no charge. Also located on the grounds of Camp Marcella is the Zeek Cemetery, which dates to the 1820s.

Five

GREEN POND

Green Pond began as a small, spring-fed lake thousands of years ago. It drained to the north into the Pequannock River system. Then, 10,000–15,000 years ago, the Wisconsin Glacier moved through the area, depositing glacial till at the northern end of the lake. This caused the water to drain to the south through Picatinny Brook and on into the Rockaway River system. The advancement and receding of this glacier deepened and enlarged this pristine lake, which is approximately three miles long and a half-mile wide.

The Lenape Native Americans occupied this lake area until the late 1700s when they began to migrate west to avoid the influx of European settlers. The Green Pond iron mines were opened in 1872 and were worked until about 1899 when they were abandoned because of an unfavorable ore market.

After the closing of the mines, vacationers arrived to enjoy the excellent fishing and the solitude of the wilderness. Green Pond joined the parade of locations that became revival sites, with camping and family life based on bible teachings. Looking for relaxation, city dwellers came by train and were transported to the lake in horse-driven wagons, to spend time fishing, hiking, boating, and swimming in the country. In the early 1900s, summer cottages were constructed to take the place of the original campsites. Over the years more summerhouses were erected, which were later upgraded into year-round homes.

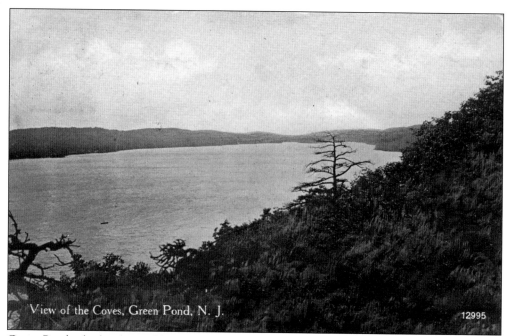

View of the Coves, Green Pond, N. J.

12995

Green Pond, which is located between the Green Pond Mountain on the west and the Copperas Mountain on the east, is a 460-acre glacial lake. This photograph was taken from White Rock, a favorite hiking destination.

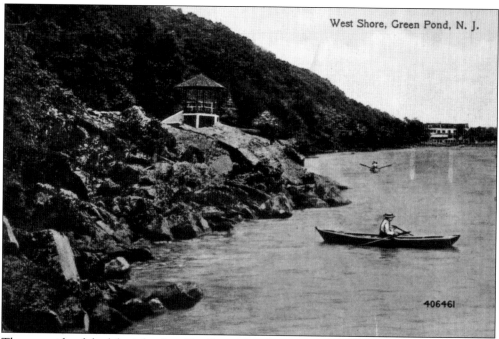

West Shore, Green Pond, N. J.

406461

The west side of the lake is bordered by Green Pond Mountain, a vertical mass of conglomerate rock. This mountain rises nearly 200 feet from the water at this location. Homes bordering the west shore can only be accessed by a walking path or by boat. The Green Pond Hotel is visible in the distance.

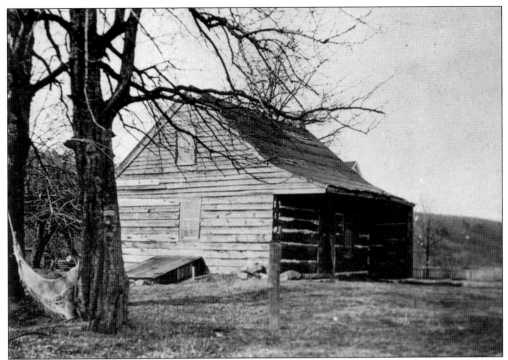

John and Elizabeth (Allison) Egbert built this log cabin in 1862. Andrew Bell Cobb, builder of the Split Rock Furnace, owned land in Greensville, which later became Marcella. He exchanged his land and residence in Marcella for the John Egbert property in Green Pond. The cabin later served as a post office and is presently being used as the offices of the Green Pond Corporation.

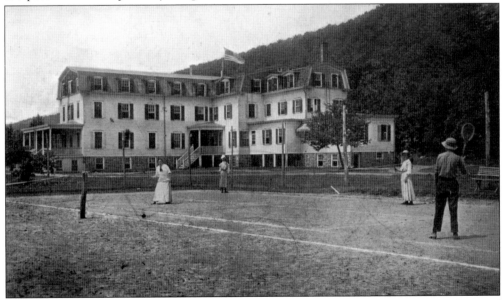

The Green Pond Hotel was built in 1905. From the hotel verandah there was a beautiful view of the lake and the surrounding mountains. Lighting was by acetylene gas, and steam heaters and open fires provided heating. The hotel even had hot and cold running water. Delicious meals were served to the guests in the hotel restaurant.

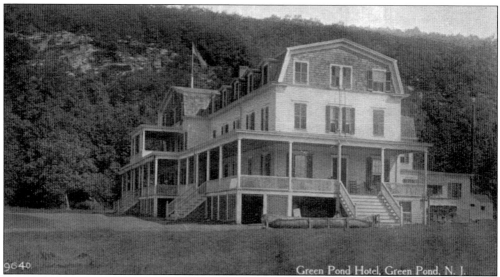

In addition to swimming, boating, and fishing, a wide range of activities was offered at the hotel. There was dancing, tennis, croquet, bowling, and even horseback riding. In the 1950s, fewer people came to vacation at the hotel, and in 1961 it was demolished.

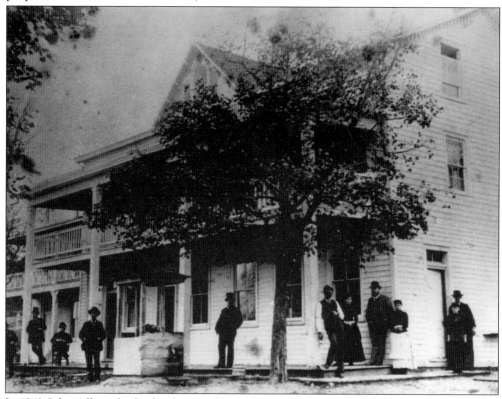

In 1842, John Allison built what became known as the Davenport Hotel. He retained ownership for two years, and in 1844 he sold it to James Davenport. In 1881, after improvements and an expansion project, the hotel could accommodate 100 boarders. It was destroyed by fire in the early 1900s and was never rebuilt.

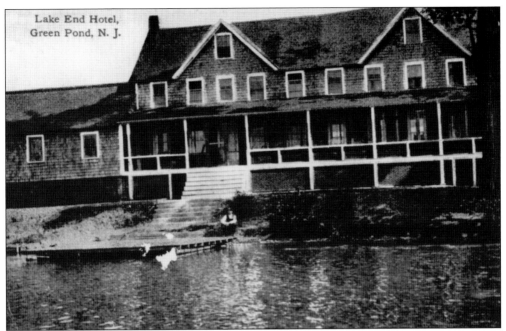

The Lake End Hotel, located on a quiet cove of Green Pond, attracted fishermen, sportsmen, and vacationers. This small hotel, built in the late 1800s, offered a homey and comfortable atmosphere. The proprietors limited the number of guests, who enjoyed tennis, boating, swimming, fishing, and hiking.

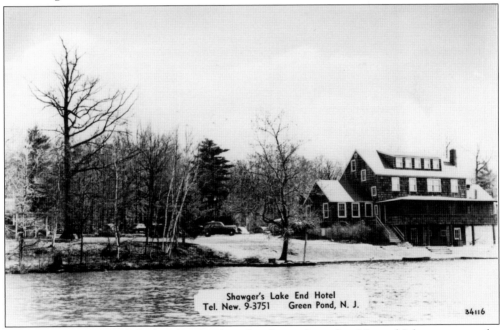

Mr. Shawger purchased the hotel and enlarged it. It was here that Howard Johnson wrote the song, "When the Moon Comes Over the Mountain," which later became Kate Smith's theme song. In the 1930s, the hotel was destroyed by fire, but was later rebuilt. It became a private residence in 1957.

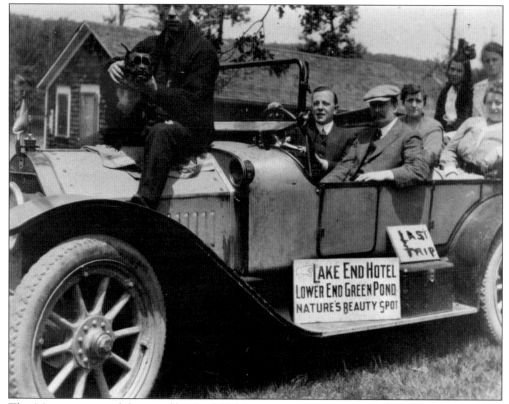

This Marmon automobile owned by Frank White transported vacationers from the train station in Newfoundland to the Lake End Hotel. Passengers included Jim Blake, Neil White, ? Shawger, Wilma White, and Mrs. Frank White. The building in the background is the bar room of the hotel.

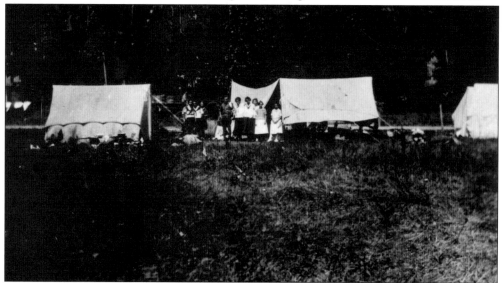

In the late 1800s, people discovered the beauty of Green Pond and returned year after year to camp here. This photograph of a Green Pond camp on Bonnie Brae Road was taken in 1921. The lake was used for drinking and bathing.

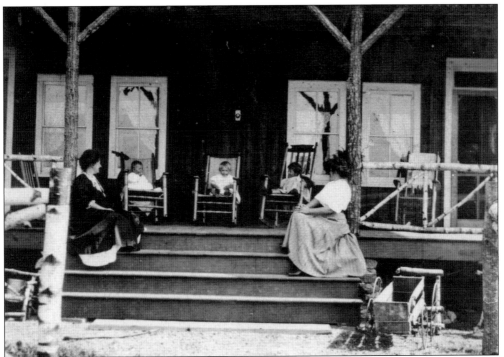

In 1890, Charles Struppmann and William Wollen arrived at Green Pond and met two sisters, Barbara and Mary Bible. Each man courted and soon married one of the two women. They returned year after year with their growing families to vacation at Green Pond.

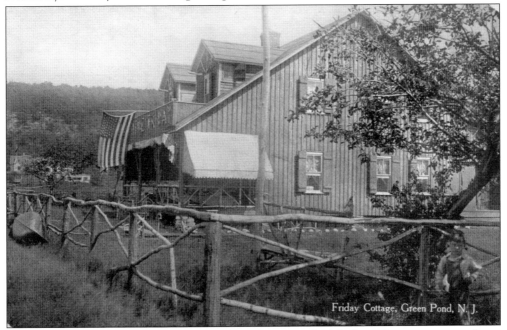

Friday Cottage, Green Pond, N. J.

Eventually, the two families built the first large house on the lakefront. It was constructed as a two-family home with identical rooms on each side. The house, which still stands, was called Cottage Friday because Friday was considered a lucky day for the families.

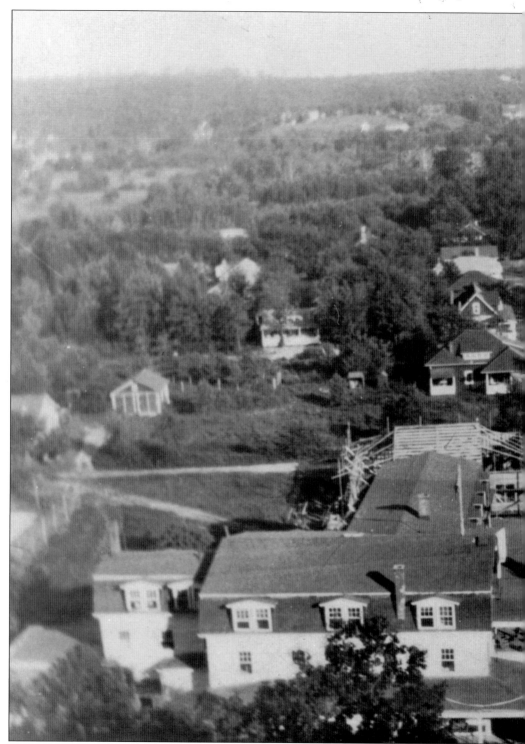

This 1912 photograph shows how Green Pond began to flourish as a summer vacation area. The Green Pond Hotel is in the foreground, and directly behind it is the community house, which

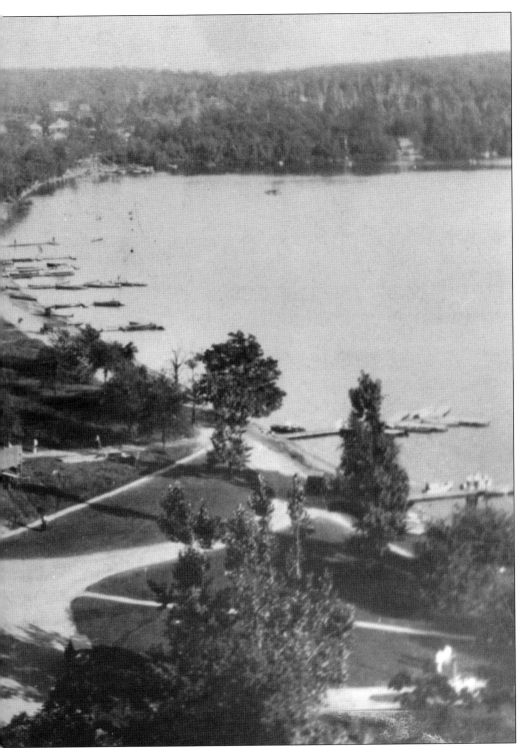

was under construction. In the background, many summer cottages are visible.

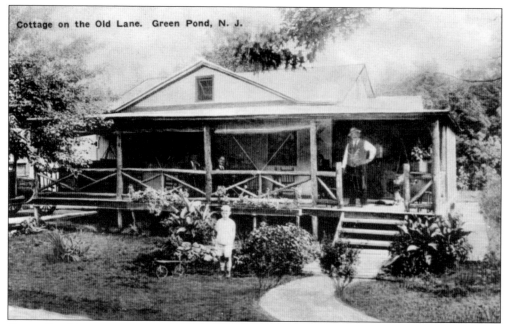

Cottage on the Old Lane. Green Pond, N. J.

Green Pond became increasingly popular. People began leasing property and building small summer cottages, such as this one located on Old Lane. Due to the relaxed lifestyle of summer, many cottages had porches to entertain family and guests. Children made friendships, which they renewed every summer.

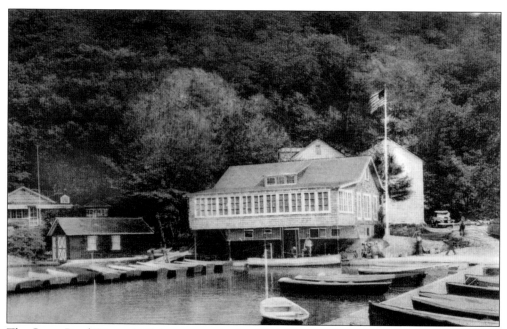

The Green Pond Women's Club was organized in 1924. The members planned activities for all age levels of the community. In 1927, Harry Post of Newfoundland, New Jersey, erected a clubhouse for the group. It was built on top of the boathouse, and it contained a community room and a kitchen. This building is no longer in existence.

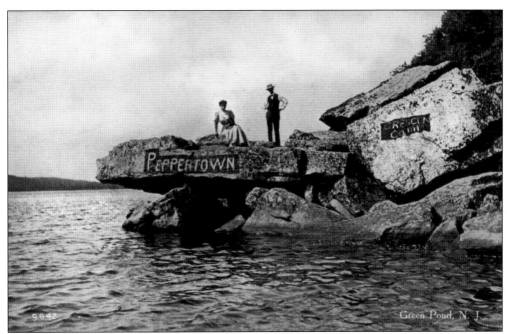

A story from the *Newark News* of 1925 explains how Peppertown Rock got its name. In the early 1900s, some young people from Boonton were nicknamed the Peppertown Bunch because the pranks they played were "such hot stuff." When the group camped at Green Pond, they would venture onto this rock to sing and watch the sunset. One day, Francis E. Norris painted the name Peppertown on the rock.

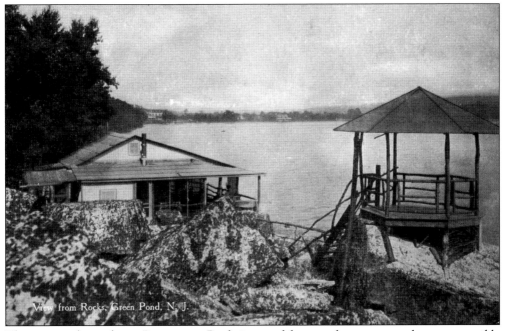

This cottage, located near Peppertown Rock, is one of the west-shore cottages that are accessible only by boat or footpath. The gazebo still exists, but without its roof.

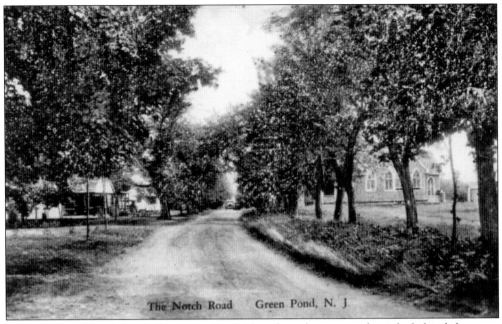

Upon entering Notch Road, the Green Pond Chapel can be seen to the right behind the trees. At one time, this road used to continue over the mountain to Jefferson Township.

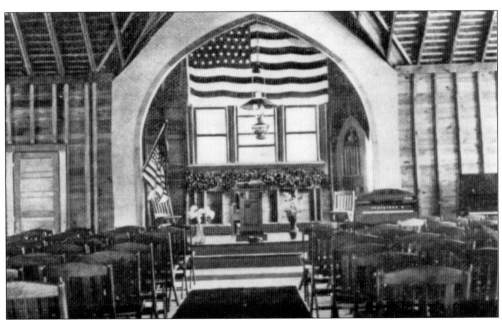

In 1909, a group of women organized the Women's Cottage Club. Their objective was to plan religious and social events for the community. In 1922, the Cottage Club purchased land on Notch Road and hired Frank Van Dien to construct the Green Pond Chapel. This interdenominational chapel has been renovated and improved over the years.

This picture shows one of the unimproved dirt roads that led to Green Pond from Denville to Newfoundland.

Green Pond has evolved from a summer resort to a year-round community of close-knit families.

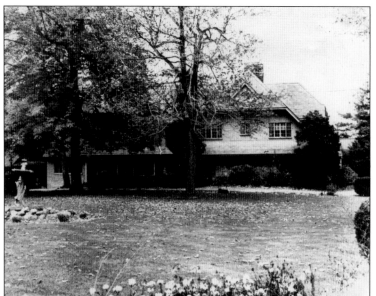

This home, which was constructed of stone and stucco in the early 1900s, was known as the Dryden Estate. In 1946, Margaret Dryden sold her property, which consisted of 9.5 acres, a 12-room residence, a home for the caretaker, and two garages, to Augustus Merolle. He was an immigrant from Italy, and one of the inventors of the screw-on bottle cap.

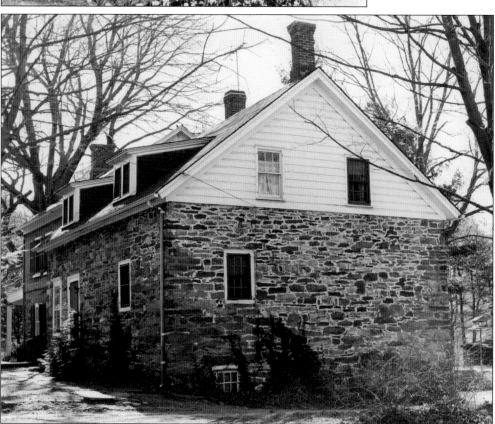

The Stone Cottage consisted of two small dwellings with a carriage drive between them. By the 1750s, the Demouth family owned this property. Their daughter married Peter Snyder in 1773. In 1820, the houses were inherited by the Snyders, who remodeled them and joined both together to make one house. At the same time a second story was added.

Six

LAKE TELEMARK

In 1929, Stephen and Hallvard Bergdal created Lake Telemark by damming Hibernia Brook. The lake was named in honor of their birthplace in Norway. Their dream was to establish a vacation community for their fellow Norwegian immigrants who lived in Bay Ridge, Brooklyn, New York. The Bergdal brothers made an agreement to donate two lakefront lots to the Bondeungdomslaget (Young Farmers Association). This Norwegian organization built a lodge and started the summer colony.

In 1930, club members, using local chestnut trees, built the original BUL (Bondeungdomslaget) Cabin as a vacation place and weekend retreat. As families ventured out to Lake Telemark and enjoyed the camaraderie of their fellow Norwegians, some purchased property and built summer homes. There were two Norwegian organizations in Lake Telemark, the BUL and the Norseman Lodge, Sons of Norway. In 1978, they merged and took the name Nor-Bu Lodge.

The Lake Telemark Clubhouse was built between 1929 and 1930 by the Lake Telemark Country Club for the people who lived in Lake Telemark. Through the years the organization has provided a variety of activities for the community as well as a place for people to gather and socialize.

Members of the Odin Ski Club built the Lake Telemark 30-meter ski jump in 1948. It was constructed on a slope near North Cape Trail under the supervision of Art Tokle Sr. and Erling Flogland.

Some of the street names in Lake Telemark have interesting origins. Hallvard Terrace is named after Lake Telemark founder Hallvard Bergdal. Oslo Drive, Bergen Hill Road, and North Cape Trail are named for towns in Norway. Torden Place was named for Peter Wessel, vice-admiral in the Dano-Norwegian Navy (Norway being ruled by a Danish king at the time). When he was raised to the nobility, Peter Wessel was given the name of Tordenskjold (literally Thundershield). Tordenskjold Place was shortened to Torden Place.

Most of the vacation homes have been converted to year-round houses, and many new homes have been built. The Nor-Bu Lodge and its members continue to strive to preserve the Norwegian culture of this community.

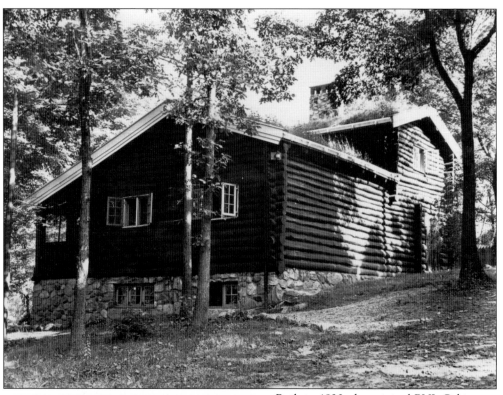

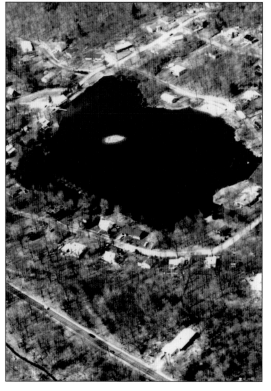

Built in 1930, the original BUL Cabin spearheaded the development of the community of Lake Telemark. Guttorm Christie, a notable Norwegian architect, designed it in the Norwegian log cabin style. The cabin was originally used as a vacation place and weekend retreat and has become a center and focal point for Norwegian culture.

In the 1930s and 1940s, Norwegian families began buying lots on which to build their own vacation cabins. In the 1950s, many began converting these homes to year-round dwellings.

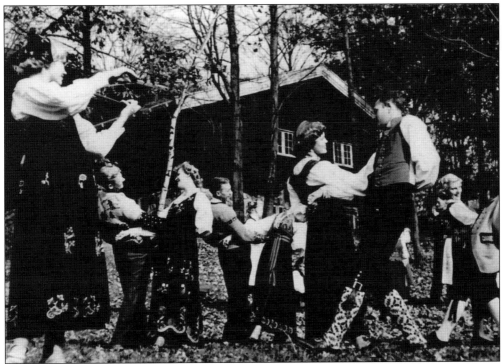

Folk dancing has always been an important part of the social scene at the BUL Cabin. These women are dressed in their traditional Norwegian costumes, called a *bunad*. These costumes, which were exquisitely hand-embroidered, represented the place of origin of the dancers' families in Norway.

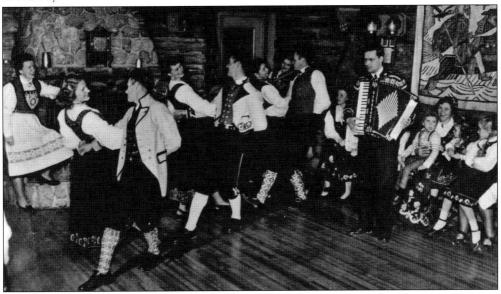

Many people traveled from Brooklyn to enjoy a night of Norwegian folk dancing at the BUL Cabin. The gentleman playing is Walter Erikson, who was a very popular and talented accordion player. To the left of the accordion player is Chris Lund. When he was 17, he painted some of the interior woodwork with rosemaling, "rose painting," a traditional Norwegian folk art.

The cabinet in the corner was decorated using rosemaling. Every province in Norway has its own special style using different colors and patterns. Standing from left to right are Ellen Christoffersen (left), Carol (Andreassen) McKeon (center), and Barbara (Hegg) Cerullo. Seated are Marie Ostevik (left), Charles Fossum, and Inez (Fossum) Torgersen, also known as "Bunny."

Club members built this rustic bridge in the 1940s. It connected a small island to the backyard of the BUL Cabin. Inez (Fossum) Torgersen recalls "Pop" helping to build the bridge. She remembers the parties and picnics on the island, where everyone would sit and listen to accordion music.

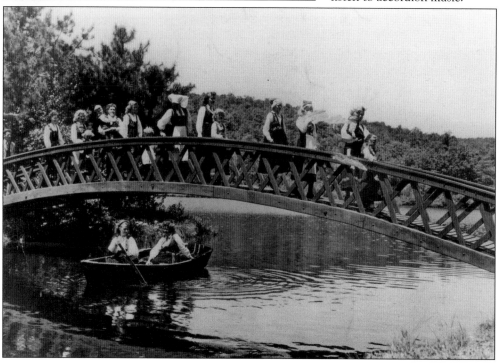

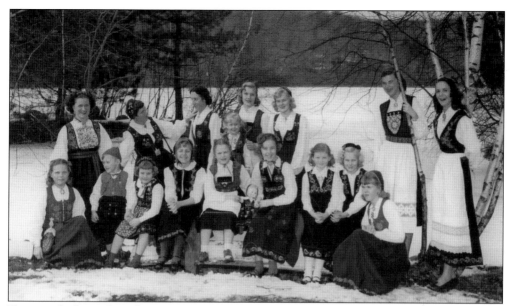

Photographed in 1952 in their Norwegian costumes are (first row) Ellen (Skavnes) Tonnesen, Charles Fossum, "Bunny" (Fossum) Torgersen, Ellen Christofersen, Barbara (Hegg) Cerullo, Vencka (Stene) Lunde, Marie (Ostevik) Tobiassen, Thelma Pedersen, and Evelyn (Skavnes) Hansen; (second row) Carol (Andreassen) McKeon; (third row) Ruth Skavnes, Magny (Landstad) Jensen, Sofie Justnes, Star (Jensen) Trondsen, Sonja Pedersen, Elinor (Ostevik) Beyer, and Molly Bergdal.

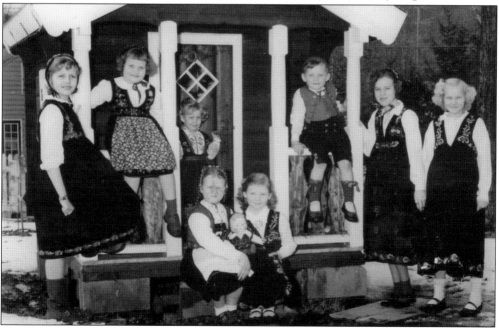

This log playhouse on Telemark Road was built by Hallvard Bergdal. Posing from left to right in front of the playhouse, which is a replica of a Norwegian home, are Ellen Christoffersen, "Bunny" (Fossum) Torgersen, Carol (Andreassen) McKeon (in doorway), Barbara (Hegg) Cerullo (seated), Marie (Ostevik) Tobiassen (seated), George Charles Fossum, Vencka (Stene) Lunde, and Thelma Pedersen.

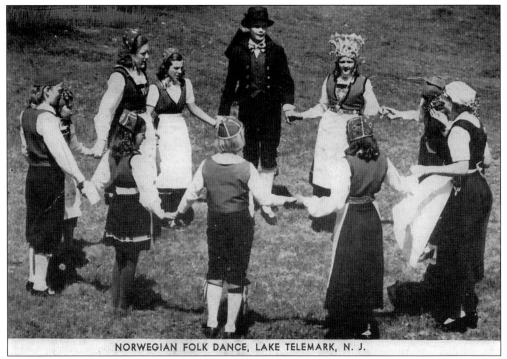

NORWEGIAN FOLK DANCE, LAKE TELEMARK, N. J.

In this picture students are demonstrating a Norwegian wedding celebration. The bride would have worn a wedding crown similar to the one pictured here.

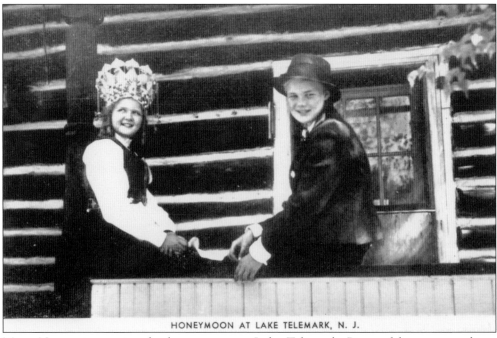

HONEYMOON AT LAKE TELEMARK, N. J.

Many Norwegians enjoyed a honeymoon at Lake Telemark. Pictured here are students Esther Bergdal (daughter of Hallvard Bergdal) and Evelyn (Barth) Hammaren (right) in traditional costume depicting a typical honeymoon couple.

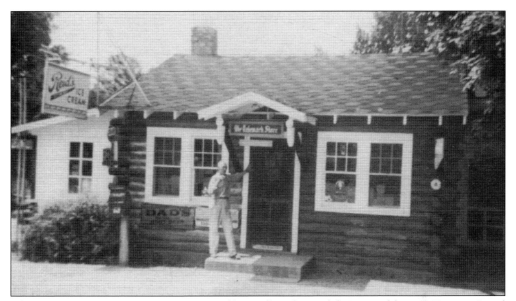

About 1928–1929 a store was constructed by Hallvard Bergdal. Pictured here is Kristian Lund Sr. About 1934, a tavern was added to the store, but at that time it was operated more as a social club than a bar. Many remember musicians who kept the lively group of dancing patrons happy by playing old-world music. This store was later owned by Gus and Dora Hofseth.

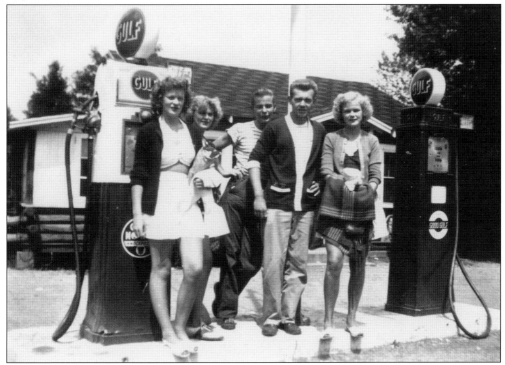

Pictured in front of the Lake Telemark Store are Greta Bjercke, unidentified, unidentified, John Nilsen, and Evelyn Barth. Evelyn grew up in Lake Telemark. In 1935, when her family moved here from Brooklyn, their home had no indoor plumbing or electricity. She attended the Hibernia Grammar School.

The construction of a dam created Lake Telemark, which is a man-made lake hand-dug from a swampy area. As late as the 1950s, the roads in Lake Telemark remained unpaved.

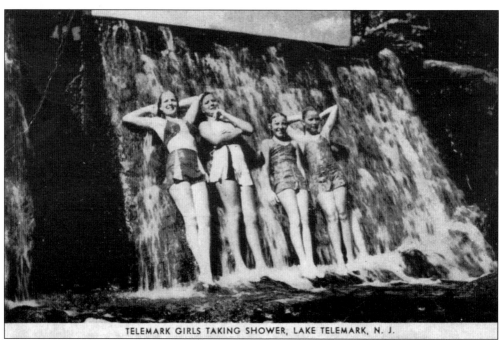

TELEMARK GIRLS TAKING SHOWER, LAKE TELEMARK, N. J.

These Telemark girls are shown cooling off under the waters flowing over the dam.

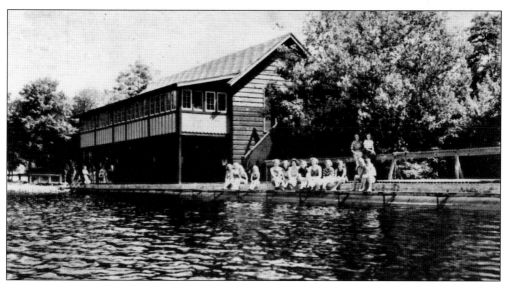

The Lake Telemark Country Club maintains the beach and the lake. Its Women's Club plans events such as the ice cream social and the Easter egg hunt. The Men's Club coordinates the Fourth of July fireworks, Saint Patrick's Day dinner, lobster/clam bake, comedy night, and other activities. A room overlooking the lake is used for a variety of functions.

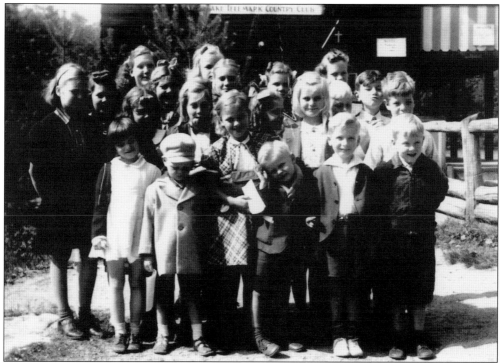

Pictured here are the children from the Sunday School class taught by Bergit and Roy Nicolaysen at the Telemark Country Club. From left to right are (first row) Lillian Carlsen, Bob Sutherland, Edith Thorsen, Robert Jacobsen, Eddie Jacobsen, and Martin Solberg; (second row) Betty Hansen, Carol Jones, Jackie Jones, Ann Nakken, and Norma Barth; (third row) Alice Pedersen, Evelyn Barth, and Greta Bjercke. In 1942, the Sunday School classes were moved to the church in Hibernia.

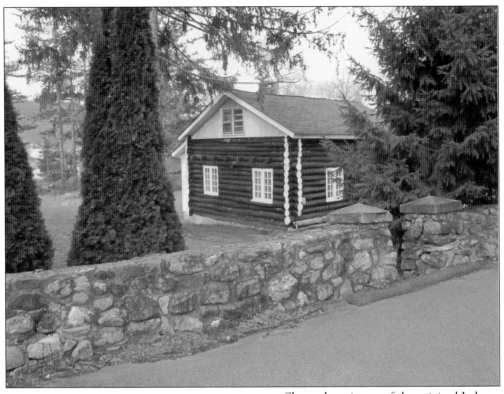

Shown here is one of the original Lake Telemark log cabins. Built in 1929, this traditional Norwegian home was made from chestnut logs. It was later purchased by Gerd and Al Andreassen.

Improvements were made to the Lake Telemark ski jump, and it was utilized through the 1950s. To stop, ski jumpers had to slide into bales of hay. These bales were provided by Earles's farm in Marcella. On Memorial Day 1957, a summer ski jumping event was held using crushed ice from Dalrymple's Ice House in Randolph. The ski jump was destroyed by fire in the 1960s.

Seven

WHITE MEADOW LAKE

In 1753, David Beman purchased land in White Meadow, where he and Thomas Miller built a forge. Abraham Kitchel bought the White Meadow Tract, which included Guinea Forge, before the Revolutionary War. He was probably the first landowner to build a house on the property. Some sources indicate that he helped to integrate the workings of local iron mines and forges to supply ammunition during the Revolutionary War.

The property was purchased by Bernard Smith, who sold it to Israel Canfield in 1802. The Stickle family eventually acquired this tract of land. In 1814, Col. Thomas Muir purchased the property from the Stickle family, and he made his residence at the house built by Abraham Kitchel after 1823. He operated the mines in White Meadow until his death in 1855. At that time, his son, Peter; his daughter, Ann Hoagland; and his son-in-law, Mahlon became the owners of this 1,700-acre estate. Ann and Mahlon had seven children, and they lived at White Meadow until Ann's death in 1893, at which time Mahlon moved to Rockaway Borough. The property was then rented to the White Meadow Fish and Game Club, which built a dam to form the lake in its present size.

Upon the death of Mahlon Hoagland in 1907, his son, Thomas, became the owner of the White Meadow Lake property. By 1909, he had begun construction of a new home that would become known as the Hoagland Mansion. After Thomas's death in 1928, his daughter Evelyn (Bayles) inherited the property.

In 1945, the White Meadow Lake Tract was sold to the Kline family of National House and Farms Association Inc., which decided to develop it as a vacation community. The Hoagland Mansion became the White Meadow Lake Clubhouse, the center of activity for this lake community. In 1954, all the facilities at White Meadow Lake were transferred to the Property Owners Association.

With the completion of Route 80 in the 1970s, new owners purchased the summer cottages and began converting them into year-round homes. Since that time many new houses have been constructed. Presently, there are approximately 2,500 dwellings in the White Meadow Lake community.

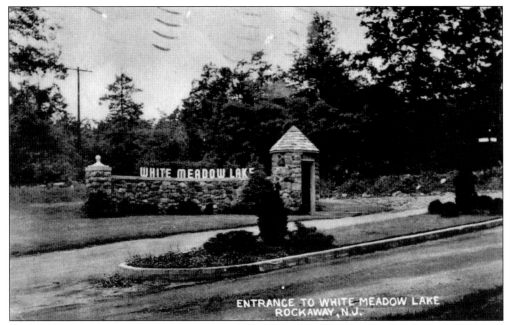

Over 240 years ago, records indicate that the White Meadow Tract encompassed over 1,500 acres. Tradition has it that the name White Meadow originated with the first settlers, who attributed the naming of this community to the white morning mist or white wildflowers growing in the marshy area that is now the lake.

At one time, this small dirt road was the only access to the White Meadow Tract. It is now the location of one of the present-day entrances to White Meadow Lake.

Shown at right is Peter Muir, who upon the death of his father Col. Thomas Muir in 1855, inherited the White Meadow Lake Tract along with his sister, Ann (Hoagland).

Abraham Kitchel built the first house on the White Meadow Tract in the 1700s, which later was occupied by the Muirs and then the Hoaglands. The boy on the swing is Hudson Hoagland (b.1899). His sister, Louise (Hoagland) Baylis, is seated with her grandmother, the wife of Thomas Hudson Hoagland (1851–1926). Behind the swing is Hudson's grandfather, Thomas Hudson Hoagland (1851–1926). The man leaning on the tree is Hudson's father, Mahlon Lounsbury Hoagland (1871–1918).

This photograph of four generations of Hoaglands was taken *c.* 1905. Hudson Hoagland is the young boy in the front. Standing behind him is his father, Mahlon Lounsbury Hoagland. On the right is Hudson's grandfather, Thomas Hudson Hoagland, and on the left is his great-grandfather, Mahlon Hoagland.

After the death of his wife, Mahlon Hoagland moved to Rockaway Borough. He leased his White Meadow property to the White Meadow Fish and Game Club, which was an exclusive club limited to 50 members. This club reconstructed the dam and enlarged the lake.

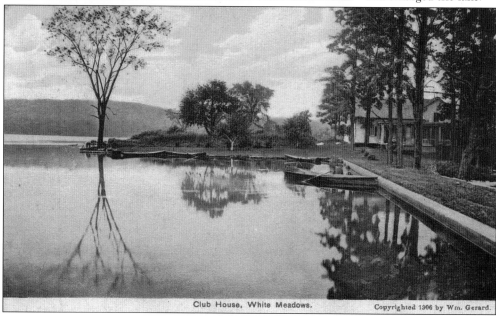

Club House, White Meadows.　　　　Copyrighted 1906 by Wm. Gerard.

114

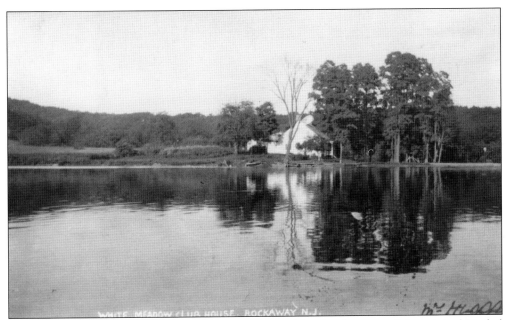

When Mahlon Hoagland died in 1907, his son Thomas Hoagland renovated the original Kitchel House, and it became the residence of Thomas and his wife, Evelynne E. Lounsberry. At that time, an addition facing White Meadow Road was constructed. The house then contained 14 rooms.

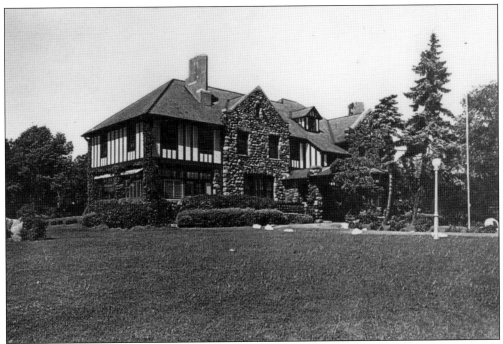

In 1909, Thomas began construction of a new home, located behind the old Kitchel house. Built of fieldstone and other materials, the Hoagland Mansion was one of the most elegant, lavish homes in the area.

This 1923 photograph shows the road approaching the Hoagland Mansion, which can be seen in the background.

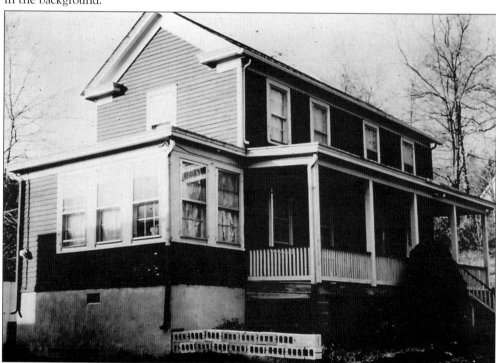

After the new mansion was constructed, the addition to the Kitchel house was moved across the road to its present site behind the White Meadow Temple. Chauffeurs, caretakers, and farmers for the Hoagland estate were housed in this building. The temple congregation later purchased the house, and they are the present owners. The original Abraham Kitchel House was torn down.

Thomas Hoagland created a sunken rose garden in the foundation of the original Kitchel home. A staff of about ten people maintained the mansion, lawns, and gardens.

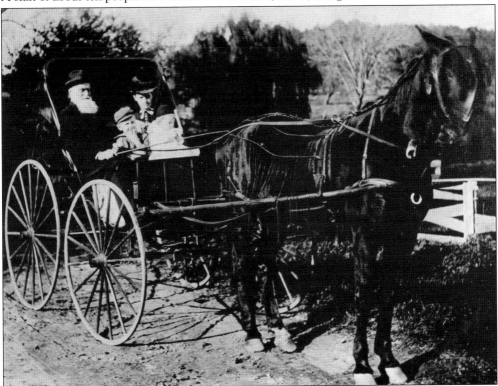

The Hoagland family was of Dutch descent. They arrived from Holland in the 17th century and settled in New Amsterdam. Maj. Christopher Hoagland (1742–1813), a Revolutionary War soldier, was the first Hoagland to own property in Rockaway. Pictured in the buggy in front of the Hoagland Mansion are Hudson and his sister, Louise, with their great-grandfather, Mahlon, and their mother.

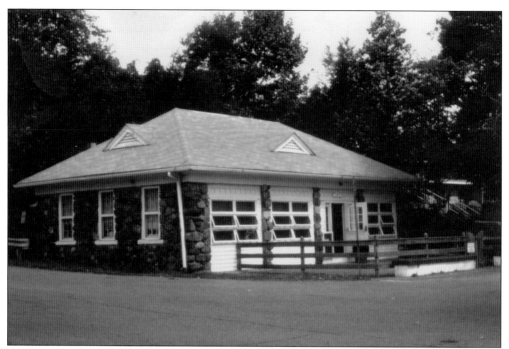

The Hoaglands' carriage house was located across from the mansion. Carriages, harnesses, and other equipment were housed here. This building is presently a preschool for residents of White Meadow Lake.

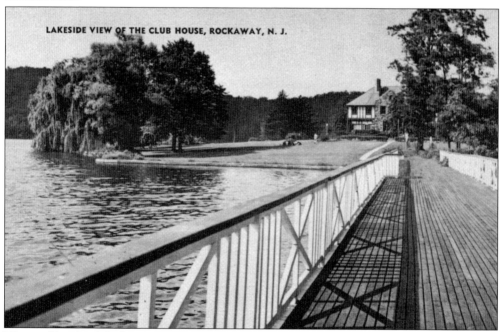

LAKESIDE VIEW OF THE CLUB HOUSE, ROCKAWAY, N. J.

Thomas Hoagland died in 1928, and his daughter, Evelyn, who had married Chester Baylis, took possession of the house. In 1942, the estate was sold to Warren Foundry and Pipe Company, which in turn sold it in 1945 to National House and Farms Association Inc. This company was a long-established organization with over 50 years of experience developing communities.

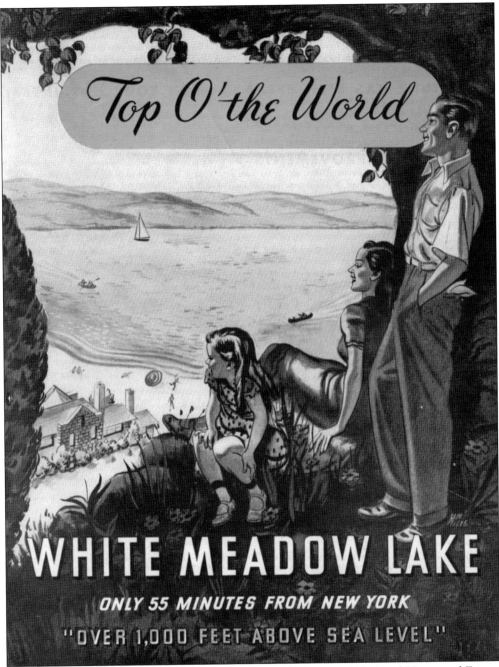

The Kline brothers (Benjamin, Morton, and Norman), owners of National House and Farms, developed White Meadow as a lake vacation community. In addition to the Hoagland property, additional acreage was acquired from the Spear, Stickle, and Oram estates. Altogether 1,500 acres were acquired by the Klines, who wanted to create an alluring and attractive residential and vacation community around one of the largest private lakes in northern New Jersey.

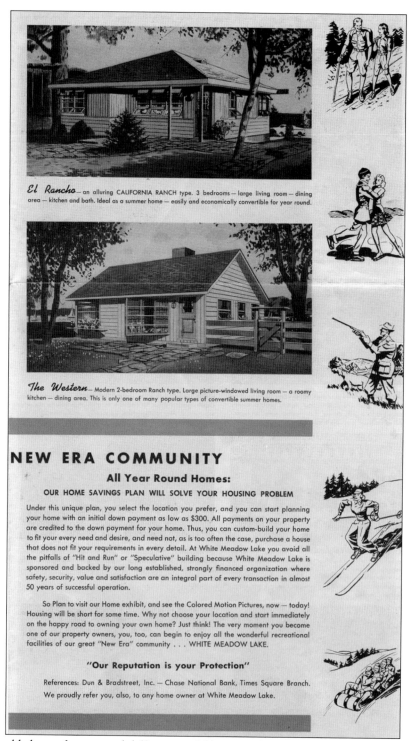

El Rancho — an alluring CALIFORNIA RANCH type. 3 bedrooms — large living room — dining area — kitchen and bath. Ideal as a summer home — easily and economically convertible for year round.

The Western — Modern 2-bedroom Ranch type. Large picture-windowed living room — a roomy kitchen — dining area. This is only one of many popular types of convertible summer homes.

NEW ERA COMMUNITY

All Year Round Homes:

OUR HOME SAVINGS PLAN WILL SOLVE YOUR HOUSING PROBLEM

Under this unique plan, you select the location you prefer, and you can start planning your home with an initial down payment as low as $300. All payments on your property are credited to the down payment for your home. Thus, you can custom-build your home to fit your every need and desire, and need not, as is too often the case, purchase a house that does not fit your requirements in every detail. At White Meadow Lake you avoid all the pitfalls of "Hit and Run" or "Speculative" building because White Meadow Lake is sponsored and backed by our long established, strongly financed organization where safety, security, value and satisfaction are an integral part of every transaction in almost 50 years of successful operation.

So Plan to visit our Home exhibit, and see the Colored Motion Pictures, now — today! Housing will be short for some time. Why not choose your location and start immediately on the happy road to owning your own home? Just think! The very moment you become one of our property owners, you, too, can begin to enjoy all the wonderful recreational facilities of our great "New Era" community . . . WHITE MEADOW LAKE.

"Our Reputation is your Protection"

References: Dun & Bradstreet, Inc. — Chase National Bank, Times Square Branch. We proudly refer you, also, to any home owner at White Meadow Lake.

Buyers could choose from several different model homes, which were all custom built to suit the buyer. The El Rancho was a California ranch style. It had three bedrooms, a large living room, a dining area, and a kitchen and bath. The Western was similar, but only had two bedrooms.

120

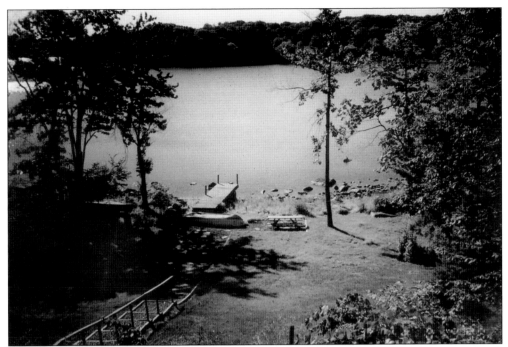

Lots could be purchased for $1,200. With $300 as a down payment and monthly payments of $15, a buyer could own one of these lots. Year-round houses could be bought for as little as $8,990 and summer homes for $4,990.

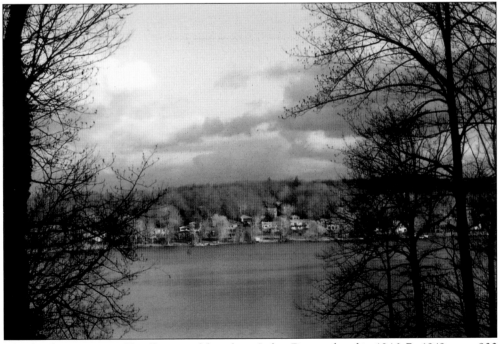

The development was officially opened for sale on Labor Day weekend in 1946. By 1949, some 900 lots had been sold and 100 homes had been built. The Kline family continued to invest millions of dollars to make this community a success.

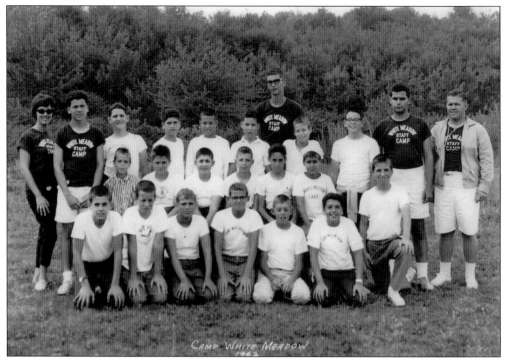

To entice people to purchase property and build homes, Benjamin, Morton, and Norman Kline decided to subsidize the cost of a day camp, which was free for residents. In retrospect, the Klines believed that this was one of their most successful endeavors in attracting people to White Meadow Lake.

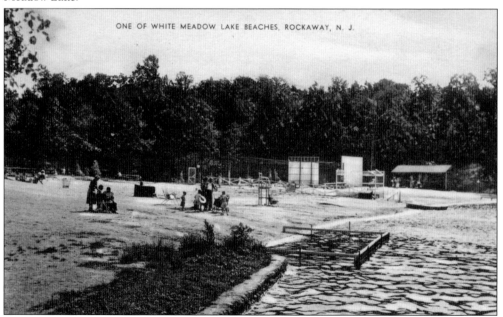

The Klines also created a variety of recreational sites, including three sandy beaches, two pools, and tennis courts. The clubhouse became the focal point of social activities for the community. The lake provided a variety of activities such as swimming, boating, and fishing.

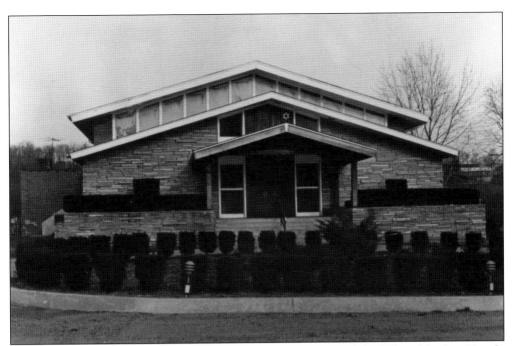

Although it was chartered in June 1952, the original structure of the White Meadow Temple wasn't dedicated until September 1953. The Kline brothers donated the lumber and land for its construction.

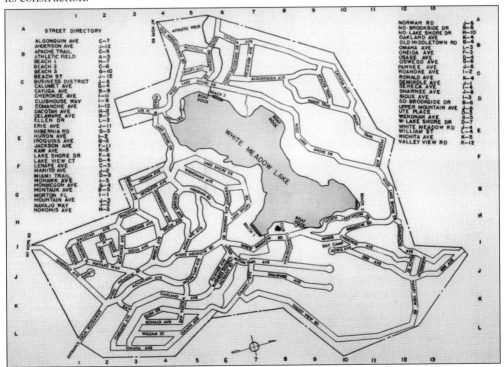

Building hard surface roads in this area was one of the biggest challenges for the Klines because of the difficult terrain. This map shows the intricate system of roads designed by them.

123

The Rockaway Township Quilt was created by volunteers during the Bicentennial as a way of celebrating the 200th birthday of the United States. The initial project called for 30 squares,

but in the end 40 quilt squares were completed. The quilt was entered in the Great Quilts of America Contest and was chosen as a state finalist from New Jersey.

Bicentennial Logo	Upper Hibernia School	Green Pond Golf Course	Holy Trinity Ch
Gunilla Nilsson	Lillian Fehr	Mary Weiss	Lillian Sandstr
Hibernia Firehouse	Mine Crusher	Hibernia Inn	Mount Hope Sc
Betty Fox	Louise Greenwood	Elsie Svaasand	Janeen Lienha
White Meadow Temple	James' General Store	Mount Hope Church	White Meado Lake Clubhou
Gladys Portalatin	Nancy Vadillo	Doris Vrabel	Louise Greenw
Ford/Faesch House	1834 House Hariett Eike	Marshall's Store	Rockaway Tow Library
Linda Monrad	Lorraine Benderoth	Julia Potter	Nora Johans
Township Seal	Lower Hibernia School	Marcella School	William J. Hend Homestead
Sally Mueller	Beth Anderson & Tina Kristiansen	Ellen Baird Diana Miller	Lindann Boutu

1976

ROCKAWAY TOWN
HISTORICAL SOCIE

Hibernia,

This quilt was designed and constructed by women of Rock
displayed in the Township and proceeds from the sale of thi

35736-D

These are the names of the volunteers who completed a quilt square. They ranged in age from 13 to 80. Fond memories of many quilt meetings will be told and retold for many years. The quilt

ernard's Church	Hibernia General Store	Mt. Pleasant School	Motto & Miner's Hat
Bette Burke	Judy di Palma	Pat White	Muriel Kowalski
ke Telemark	St. Clement's Church	B. U. L	Officer's Home Picatinny Arsenal
ary Storniello	Carol Moscatiello	Barbara Selland	Barbara Hastey
ne Homestead	U.S. Naval Power Depot	Beaver Dam	Miners & Mine Car
athleen Aste	Ruth Thorsen	Virginia Lienhardt	Lynda Kacicz
ert Homestead	Split Rock Furnace	Telemark Ski Jump	Hibernia Church (Interior)
igne Stefany	Jill Dickerson	Oddfrid Tokle	Jenny Berntsen
tone Cottage	Telemark Store	Zeek Cemetery	Municipal Building
arbara Hastey	Ruth Hansen	Susan McCauley	Natalie Haney

Photographed by: Ed Monskie, Dover, New Jersey

ICENTENNIAL QUILT
THE ROCKAWAYS

ey 07842

wnship and was presented to the Historical Society. It will be
d will be used for historic purposes.

is on display in the Rockaway Township Library.

www.arcadiapublishing.com

Discover books about the town where you grew up, the cities where your friends and families live, the town where your parents met, or even that retirement spot you've been dreaming about. Our Web site provides history lovers with exclusive deals, advanced notification about new titles, e-mail alerts of author events, and much more.

Arcadia Publishing, the leading local history publisher in the United States, is committed to making history accessible and meaningful through publishing books that celebrate and preserve the heritage of America's people and places. Consistent with our mission to preserve history on a local level, this book was printed in South Carolina on American-made paper and manufactured entirely in the United States.

Find *Your* Place in History.